Lighting Techniques for LOW KEY PORTRAIT PHOTOGRAPHY

Norman Phillips

AMHERST MEDIA, INC. ⬩ BUFFALO, NY

DEDICATION

This is my second book, and I am conscious that the knowledge gleaned during a long and exciting career (and then keyed into my word processor) has come to me via diverse and sometimes unrelated sources. If, from the beginning, I had gone to school to learn what I have learned I think I would still be at school. Much of what I have learned cannot be taught in school. Additionally, so much of what has caused me to be the photographer I am has absolutely nothing to do with cameras, film, or processing.

So often we dedicate the achievement of completing a book to the obvious. Our families are the foundation for our success—especially our spouses. Then there are the photographers who have in various ways enhanced our ability to create. I am certainly deeply appreciative of the support of my wife and family, and I am grateful for the critiques and advice and knowledge of so many colleagues.

But there are also other resources that we may easily overlook—our subjects and our viewers. Portrait photography in its truest sense is about who the subjects are, what influences them, and how they affect the artist. Also important is how those who view the portrait respond to the images we have created. Even the tiniest subjects have an innate ability to communicate themselves to the portraitist, and the created image relays that to those who love them most. When strangers view the image and react as excitedly as those who commissioned the portrait, we know we have been successful. These reactions are a powerful influence for which we must be grateful. These are the influences that teach us what is important in our portraits. My clients, in their special way, have taught me to combine my artistic talents and creative skills to produce images that not only delight them but also satisfy my desire for the unusual and unique portraits that build a reputation.

All this is due to the countless clients and their trust in my dedication to their needs. Without them, I would be just another photographer looking for a meaningful role to play in human communication.

Published by:
Amherst Media, Inc.
P.O. Box 586
Buffalo, N.Y. 14226
Fax: 716-874-4508
www.AmherstMedia.com

Publisher: Craig Alesse
Senior Editor/Production Manager: Michelle Perkins
Assistant Editor: Barbara A. Lynch-Johnt

ISBN: 1-58428-120-0
Library of Congress Card Catalog Number: 2003103030

Printed in Korea.
10 9 8 7 6 5 4 3 2 1

Table of Contents

Acknowledgments

When we "pen" a book of this nature, it requires a lot of contributions from a supporting cast. Michelle Perkins, my editor, does an outstanding job of making sure I do not confuse you, the reader, and ensures that there are no obvious errors. I greatly appreciate that Jeff Lubin, Edda Taylor, Kim and Peggy Wormolts, Robert (Bob) Summitt, and Dennis Craft provided images that have permitted me to highlight different areas of our craft. Each of them is an accomplished award-winning photographer. Their images help to make this book as valuable as I believe it to be. I trust they will forgive any suggestion I may have made that might lead readers to think their images are not amongst the best you will see. My analysis in several of the images is simply to suggest how we may frequently improve even the best of our work with a few tweaks here and there.

Thanks are especially due to Jennie, Heather, and Samantha for all their patience while we created some of the examples used to illustrate the techniques discussed. I know they are excited to be included in this book, and I am delighted that they were happy to work with me.

Thanks are due also to Backdrop Outlet for providing images of backgrounds used in chapter 2. Thanks also to Tom Waltz of FJ Westcott for providing photographic illustrations of light modifiers.

*H*aving written on high key portrait photography, and having enjoyed the rewards of high key photography both in customer satisfaction and in competition with my peers, I have to confess that my first love has always been low key. In addition to being emotionally moved by the works of Rembrandt, Rubens, Turner, Winslow Homer, and other great portrait painting masters for the way they used their observation of light, I am fascinated by how they saw into the shadows. These great masters had the ability to translate their inherent powers of observation into stunning works of art, but above all they had an ability to see light in a way that enabled them to immediately envisage the finished portrait with the first stroke of a brush. It is a skill or gift that the best portrait photographers also possess.

In my youth I was recognized as an accomplished pencil artist, using pencils to re-create the magic of light and its ability to sculpt the human form or create visual music with nature. Like the great painters, I also tried to use oils to recreate these impressions. Although I was a dismal failure with a paintbrush, I struck it rich when I discovered the camera. All of us who use two-dimensional tools to create the impression of three dimensions share similar techniques to show form and depth in our images. Much of what this book explores is dedicated to these skills.

In order to achieve images with impact and emotion that rival the work of great painters, portrait photographers need the same observation and appreciation of light as these artists. Every portrait photographer should study Winslow Homer's *The Country School* (which is housed at the Metropolitan Museum of Art in New York City) and absorb all the brilliant nuances of light that this master captured. Carefully observing this master-

piece is an education in the observation of light and how it shapes the human form. The lessons that can be learned by how this master painter picked up on all the angles of light from windows on three sides of his classroom will enable you to previsualize before the exposure. You will then be able to use the primary tool of our discipline: light. Too many take light for granted, and do not learn or understand techniques for its use.

■ WHAT YOU'LL LEARN
In this book, we will explore many different techniques and styles for creating exciting and emotional images. We will consider using light for high impact that might, as they say, knock your socks off. We will explore the use of light to create subtle and delicate images. We will explore how we can use just one light to create a dramatic portrait. We will work through a step-by-step exercise in creating the traditional and ever-popular classical portrait. We will also look at how some stunning images can be created using nature's own light.

Additionally, we will explore the importance of selecting the best background and props. The posing of hands and limbs and the selection of clothing is also covered, because many images with great potential either don't live up to expectations or are ruined entirely when we do not pay adequate attention to all the elements. These must come together when creating a one-of-a-kind portrait—especially in low key images, since the rendering of skin tones against a low key background is more pronounced than in other keys.

We will also look at composition and how it is perhaps more important in low key than either of the other primary keys.

■ PERSPECTIVE
Much of my own work in this book reflects my personal feelings about my subjects and how I wanted to represent them. The work of other world-class photographers is used to show how each of us may approach our subjects from a different perspective. By examining some outstanding images by these photographers, we can take advantage of an even wider variety of styles to analyze for our education.

In this book, I also want to overcome the notion that the only way to learn better techniques is through one-on-one instruction with a master of the craft. While such education is invaluable, it is just another means to an end. Analyzing images with a conscious regard for lighting, posing, and composition can be a learning exercise in itself. Professional magazines such as *Rangefinder* (published by Wedding and Portrait Photographers International), *Professional Photographer* (published by Professional Photographers of America), *Image Maker* (published by the Society of Wedding and Portrait Photographers), and *Master Photographer* (published by the Master Photographers Association) present us with insights and information of intrinsic value. But the most valuable information they present, in terms of image creation, is in the photographs they publish. If we analyze these images with the purpose of learning how they were created, then use our knowledge and the tools of the trade

to turn this appreciation into practice, we learn the skills of the masters whose work we admire. In this book, much of what is advocated is precisely this use of your powers of observation. As you read the analysis of each portrait, aim to recognize the techniques and understand the effects as each one is described.

■ ALWAYS LEARNING
It is an arrogant man who believes he has nothing to learn. When you meet the most accomplished photographers and engage them in conversation, you find that no matter how experienced they are, or how many awards they have won, they never stop learning. None of us will ever know all there is to know, or see all there is to see. Even as we teach, we learn from the student. Refining our skills requires us to be a perennial student. Personally, writing this book has reawakened me to techniques and styles that I have neglected to practice as I have advanced my style and sought new and exciting ways to create portraits that will be admired, not only by individual clients, but by everyone who sees my work. That in itself is part of the learning process.

When discussing the key in which a photographic portrait is created, we are referring to the overall tonal brightness (or lack thereof). This is perhaps better described as the saturation of color (or density) and the degree of contrast between the subject and the background.

In high key photography, there is a dominance of light and bright tones—we expect an average brightness that is at least 2 stops brighter than 18% gray. In middle key photography, the tones are in the middle of the range of tones, and the average brightness is about 1 stop higher than 18% gray. In low key photography, we are working with a dominance of darker tones and an average brightness that is equal to or darker than 18% gray.

■ CHALLENGES OF LOW KEY

The challenge in low key is to produce images that have a vitality and luminance that transcends the overall lack of bright tones, or to create images that have subtle tones and texture that draw the viewer into the inherent message. Because we are working in low key does not mean that the image has to be dull and without bright, eye-catching elements. Whether you enjoy low key images with dramatic impact, or prefer those with more subtle tones, low key portraits have a deep quality that tends to draw us in and cause us to study the image in order to appreciate its inherent beauty.

If you review the old masters' paintings, you will become aware that they are almost exclusively in low key. The primary reason for the dark tones in this work is the fact that most of it was created in candlelight or light from oil lamps, and the great majority of clothing worn by the subjects tended to be of darker tones. In these days before white leather, brightly dyed fabrics, and pastel-colored Formica, furniture was also on the darker side of the density index. Additionally, these artists did not have the advantage of fill flash

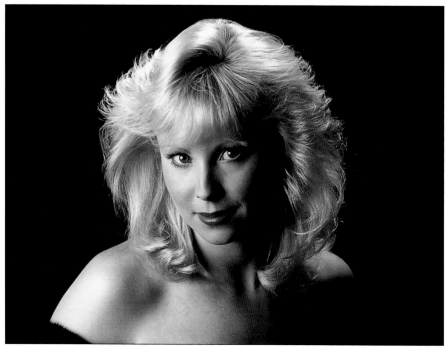

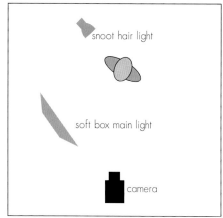

Plate 1—Dramatic three-dimensional effect created by a 5:1 ratio against a black background. An undiffused snoot hair light behind the subject strikes the far shoulder as well as the hair. See lighting diagram.

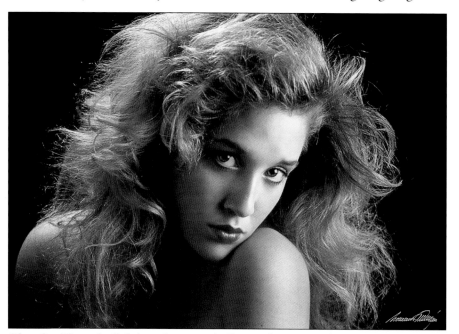

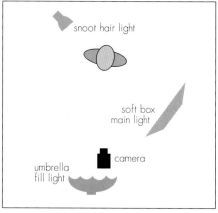

Plate 2—Here, the lighting plan was similar to the one in Plate 1. The addition of umbrella fill opened up the shadow side of the face and revealed the slightly exaggerated loop lighting pattern created by the tipping of her head toward the near shoulder. See lighting diagram.

and the idea of reflectors had not been born.

Hence, the old masters worked without the many options for improving the lighting that we will discuss in this book. Instead, they looked into the shadows and pulled out additional detail with their brushes. But in doing so they rarely increased the impression of light on backgrounds, leaving them in low key. In photography, we use reflectors or fill light to achieve the same kind of impression.

■ BACKGROUND

Generally, a portrait is in low key when the background is as dark or darker than 18% gray, and the subject is attired in tones that are not significantly brighter than the background. This means that the clothing

will be either in a similar color or a similar tone. In both color and black & white images, the primary colors (except yellow, which is in middle key) will automatically be in low key.

There are times when the deliberate use of a low key background can combine with a lighter-toned subject to form a striking image that can still be described as a low key portrait. In Plate 1, for example, the black background helps to make the subject much more provocative than if it were in any other key. A double-diffused soft box as the main light and a non-diffused hair light with a snoot modifier were employed to sculpt the subject's appearance. The hair light was positioned behind the subject so as to also light the far shoulder, which adds depth to the image. The lighting pattern dramatizes the facial structure, and there is an exaggerated loop rendering of the nose. No fill light was used.

In Plate 2, a similar technique was used, but was modified by the use of a white umbrella fill light behind the camera so as to soften the feel of the image. The hair light was again positioned behind the subject, but a little to the left to better highlight the hair. Important in this example is the harmonizing of both the main light and the hair light so the beauty of the hair is properly rendered.

Your studio- and location-lighting technique is especially important in creating effective low key portraits. This is because the modeling and rendering of your subjects' facial structures is seen in much greater relief in this key than in any other. These techniques will be covered in the following chapters.

2.
Backgrounds for Low Key

I am going to devote what might seem like a disproportionate amount of space to this element of portraiture because the selection and use of backgrounds are frequently not well thought-out. When you choose and use the background wisely, the portrait has significantly greater impact and appeal.

■ HARMONY WITH THE SUBJECT

Selecting a background that complements your subject is an integral part of creating a top-quality image. However, because of the incredible number of choices available for the background, this can be more difficult than it sounds. Often, photographers are captivated by a new background and cannot wait to use it—they purchase a background without serious consideration as to how it will be used, then use it at the first opportunity, without first previsualizing how it will influence the portrait. This can lead to the use of backgrounds that are out of character with the subject or the intent of the portrait.

Out-of-Character Backgrounds. Portraits created with backgrounds that are out of character with the subject are not uncommon. This mostly results in an image where the subject and the background compete for the viewer's attention. In many instances, you will see the background before you see the subject—which is self-defeating in a portrait, where the subject should be the center of attention.

When you get the background wrong, the portrait is clearly not as successful as it should be. While this is true in any key, it is especially so in low key because there is a much greater need for balance in the overall tonal range than in other keys. The tonal range within the background should comple-

ment the tones of the subject and not compete for attention.

Practical Example. If the subject is attired in red, a background with warm tones is preferable to one with cold tones. In such a case, the red would be better complemented with brown tones than blue. Using such criteria will result in more harmony than contradiction. This is illustrated in Plate 7 (page 20) where the subject is in a red gown. The background is painted in abstract and muted transitional tones of brown and pink that adequately provide separation between the subject and the background. In this portrait, the lighting technique is different than that used in the illustrations of the blond subjects (Plates 1 and 2). The same double-scrimmed soft box was used as the main light, but the hair light was brought more over the subject's head to allow a softer rendering of the far shoulder and an overall softer style portrait.

Most low key portraits are made against backgrounds that are predominantly at least 2 stops darker than 18% gray. Many will also be vignetted to at least 3 stops darker than 18% gray, or go to black.

■ PURE BLACK BACKGROUNDS

Some truly striking portraits can be created using a pure black background. However, a black background presents a greater challenge in creating separation between the subject and background (covered in chapter 6), which must be achieved by careful lighting. For variety, try using a black background with a shiny surface, which will create a subtle form of separation if enough light is projected across it.

■ MUSLIN AND CANVAS BACKDROPS

Considerations. Many of the creators of muslin and canvas backdrops are not photographers, and their creations are mostly based on the notion that if it is interesting to them, it will probably be interesting to us. They are often right, and photographers take the backdrops to their studios and use them. But before we commit to a backdrop, we first need to visualize our subject against it and create in our mind's eye an anticipated portrait using the backdrop. Will the colors be complementary for the average low key portrait? Are there strong lines that make placement of the subject difficult or complicate the composition? Does the pattern assist in separation between subject and background or will it create a lighting problem? Is there a natural vignette in the background or will you have to create it with light or a vignette lighting cookie?

Distracting Backgrounds. Unless the portrait being created is designed to tell a story, such as a child playing in a playroom, a background that has sharp detail may also not be the best choice. Painted backgrounds that represent buildings or other scenes need to be used with

particular care or they may appear artificial and be uncomplimentary to the subject. Such backgrounds need to be muted or present a soft look so that they act as supports to the subject and will not attract attention. Having these backdrops in sharp focus can also be distracting simply because they are two-dimensional. When someone looks at your portraits, you do not want their first impression to be "Oh! What a great background." The eye should be drawn to the subject and the background should be a secondary element in our review of the image.

Because the great majority of canvas and muslin backdrops are only 10' wide, they do not allow you to place the subject far enough away from the background to "push" the background out of sharp focus. In this case, using a longer lens will allow you to significantly reduce the background sharpness.

Separation. In Plate 3 you will see that the area immediately behind the subject is painted lighter than the rest of the background to separate the subject from the background. Most well considered canvas and muslin backdrops are made with a lighter center area that substitutes for a backlight. When this is created in the design it can be described as a

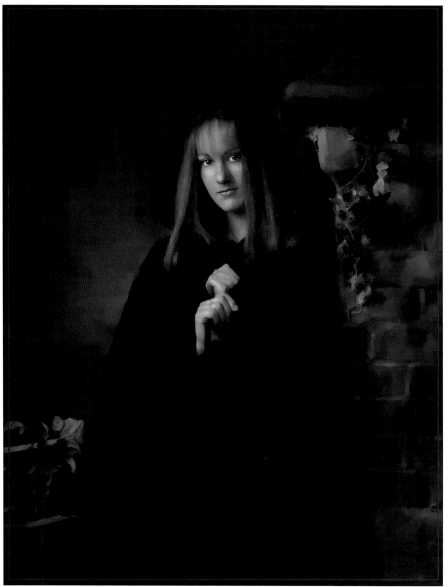

Plate 3—The light ratio in this image is difficult to recognize because the subject's hair covers her face, but the butterfly-style nose shadow suggests 3.5:1. The deep background tones and the skillful placement of the subject within the set provide appropriate separation from the background. Photograph by Jeff Lubin.

takes up a relatively small area—like an image of a bride in which the composition uses a large area of the darker church interior. In this case, the exposure difference is acceptable because the dark background and light dress are inherent elements within the composition. This is covered in greater detail in chapter 11, when we discuss composition.

■ BACKGROUND SELECTION AND PORTRAIT LENGTH

The choice of a background will be greatly influenced by the amount of the subject that will show in the final portrait.

Close-up Portraits. In a relatively close-up, head-and-shoulders portrait, you need to use a background that will be easily pushed out of focus. You do not want to use one that will draw the viewers' eyes away from the eyes of the subject.

Three-Quarter-Length Portraits. In a three-quarter-length portrait, a backdrop with a little more interest may be complementary—providing it is not out of the f-stop ratio referred to earlier.

Full-Length Portraits. In a full-length portrait, a background with greater but muted detail will be most effective.

■ SUGGESTED BACKDROPS FOR THE CAMERA ROOM

Keep in mind all of the issues discussed above when committing to a backdrop. If you consistenly consider these issues you will make fewer purchases of backgrounds that are not going to lend themselves to low key portraiture. Below is a selection of backdrops that might be successfully used in the camera room. The

painted vignette. Backdrops that do not have this type of design often require you to use some form of backlight to create the same separation, or they must be lit in such a way as to produce an image that clearly separates it from the background. This is described as a vignette by lighting. In either case, if this area of the backdrop is too bright (more than 1½ stops brighter than the overall background), it will be very

eye catching and draw attention from the subject.

■ CLASH OF KEYS

The overall background in a low key portrait should be no more than 1–1½ stops brighter or darker than the subject or it will lose its sense of harmony and create a clash of keys. The exception to this would be a portrait of a bride (or similar white-clad subject) in which the subject

Background 1

Background 2

Background 3

Background 4

Background 5

Background 6

accompanying text suggests for which style of portrait each is best suited.

Background 1. While it has a desirable bright central area that will create separation between the subject(s) and backdrop, it also has a defined scenic design that demands a lighting set that will match the scene. This background will work best with an outdoor-style portrait and ideally needs to be exposed at f-5.6 or wider, or the defined scenic will be too sharp in the portrait.

Background 2. This type of backdrop has a much larger area of brightness. The tree element at the right also requires very careful composition or it will be a distraction whether in or out of focus.

Background 3. This backdrop has even more demanding elements that will challenge your lighting and composition. This type of background is most likely limited in its application to scenic portraiture in the camera room because the subjects will need to be carefully placed

or the background will become a significant distraction.

Backgrounds 4 and 5. These are ideal for portraits with a storybook or fantasy theme. Both present a slight vignette in their tonal range and are somewhat softer than in numbers 1–3. As a result, they may be easier to push out of sharp focus and consequently may be less distracting.

Background 6. This background has a diagonal pattern with sufficiently gentle tones and contrast

to allow some portraits to be made without it being a distraction. However, the choice of this background might be limited to certain subjects that are in need of some pizzazz. It is not suited to portraits rendering character and subtle tones or ones in which you want the focus to be the eyes and facial skin tones. Diagonal patterns will always draw attention away from the subject unless they are an integral part of the composition.

Background 7. This type of backdrop features a nice balance of nondescript patterns but does not have a central area of brighter tones to help in separating the subject from the background. It will require a background light as discussed in chapter 6.

Backgrounds 8, 9, and 10. These backdrops each have a central area that is lighter or brighter than the rest of the background. They may be used without a background light. Each has a different color tone so they may be selected for use based on the subject and his or her clothing and hair color.

■ BACKGROUNDS ON LOCATION

Identifying low key backgrounds requires you to have a good appreciation of how your exposure will affect the areas behind your subjects. In a later chapter, dragging the shutter and subtractive lighting techniques are discussed to help provide control over backgrounds on location.

The background you choose to use on location is just as subjective as the choice of a background in your camera room. For low key, your on-location background will need to be at least 1½ stops darker than the lighting on the subject.

When you have found such a situation, you also need to consider the detail that may be in focus in the portrait. You will not want clutter or any eye-catching elements in the background that will draw the eye from the focal point of your portrait.

Background 7

Background 8

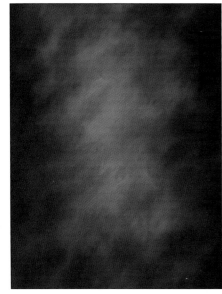

Background 9

Background 10

*H*aving defined low key and reviewed low key backgrounds, we can now consider when to use low key. When you have the option to create a portrait in any of the recognized keys, you will need to make your choice based on a number of considerations.

There are five primary elements in creating a portrait, and one reason that many portraits fail to achieve the desired result is that the photographer fails to consider all the elements as a whole. The five primary factors are:

1. Subject
2. Subject's clothing
3. Background
4. Lighting
5. Props

There is also a sixth, somewhat abstract factor. This is the concept or purpose behind the creation of the image. When presented with a subject who did not heed your advice as to what to wear for his or her portrait, this sixth element becomes more important than the other five. This means that instead of brainstorming with the client prior to the portrait session and developing an idea of what the final image should look like you are thrown into a "let's see what we should do here" situation.

■ CLOTHING COLOR

Let's imagine that the subject has arrived at her session dressed in a black long-sleeved dress. She has dark hair and brown eyes. Now you have to choose the key in which to create the portrait. A significant influence in the selection of the key is the personality of the subject. If she is bubbly with a

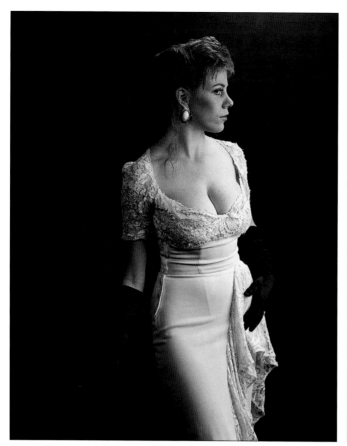 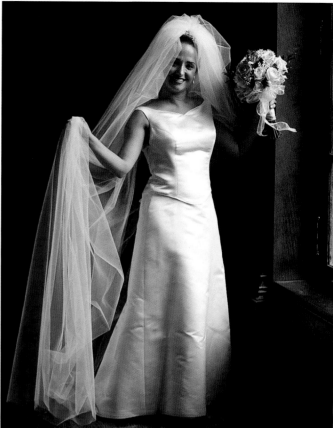

Plate 4 (left)—This portrait was designed to show off the woman's figure. Her head is in profile but her body is in a three-quarter view so that the profile lighting sweeps across her torso, accentuating her bust. Plate 5 (right)—Posing the bride at a 90° angle to the plane of the window allowed the background to drop deep into low key.

ready smile, perhaps you would be inclined to shoot it in high key. If this were your decision in this case, you would be splitting keys (mixing the low key elements of the subject with a high key background and lighting). Instead, the choice should be to create a low key portrait because, in this key, all the elements could be harmonized with the subject's clothes and coloration.

With the subject in a black dress, creating a high key portrait would present a lighting challenge. In high key, rendering texture on black garments is much more difficult than in low key. In a low key portrait, black clothing can more easily be lit in such a way as to show texture.

Another reason for selecting low key for this portrait is the mood of the portrait, an abstract element. Low key can be elegant and dramatic at the same time. Note in Plate 3 (page 14) how the woman is skillfully placed so that the subject and her black gown can be seen in relief against a well-chosen background.

If, on the other hand, the subject was attired in a white dress, high key would be more logical—although low key is still possible. Plate 4 is a studio portrait depicting the optimum balance of both a white gown and a black background that holds the image in classical low key.

A similar example of this light-on-dark style is the classic environmental bridal portrait. In this case, the scene would need to make up approximately 75% of the composition for the image to hold in low key.

This is shown in Plate 5. In this example, the portrait has been created wholly with window light.

■ HAIR COLOR

A dark- or medium-colored head of hair will look good in a low key portrait when the lighting, props, and background are carefully selected. As illustrated earlier, a blond-haired subject can be dramatically rendered in low key.

Marilyn Monroe, for example, was mostly photographed in high or middle key because it suited her bubbly personality—but imagine if you could have photographed her in low key. She was an almost larger-than-life personality, and in low key she would have been even more dramatically beautiful. Her blond hair and

sparkling smile would have created a dramatic and high-contrast impact in low key.

In Plate 6, the blond beauty may not have the same smile as Marilyn Monroe, but the rendering of a platinum blond wrapped in a white boa with delightful skin tones against a black background produces a seductive image that can still be considered low key because the background traditionally dictates the key. This principle is a little compromised by a subject that is predominantly light in tone and fills most of the frame. Compare this to Plate 7, which features a natural low key subject showing beautiful skin tones in equally beautiful relief against the dark background and deep red gown.

■ LOW KEY FOR THE CLIENT

You can see that there are different reasons why we might choose low key. The importance of consultations with clients in this process cannot be overemphasized.

In planning a portrait session, you are best advised to consult with

Plate 6—A three-dimensional lighting pattern against a black background with a seductive blond and a white boa still rates as a low key portrait. See lighting diagram.

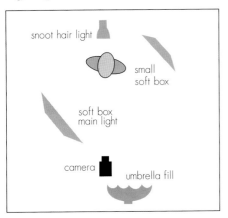

your client to discover the kind of portrait he or she is expecting. Often, this results in the client being vague or not really being able to visualize the final image. In such cases, you will need to explore their perception of portraits and how they see themselves. Ideally, you should meet with the client to get an impression of him or her and make suggestions as to what to create. You will

likely suggest a low key portrait in cases where you discover that rich tones and dramatic contrasts appeal to the client. Equally, when a client appreciates the subtleties of subdued tones, low key will generally be the best choice.

Sometimes, the client will leave the choice to your professional expertise. In this case, you will need to consider not only the elements we

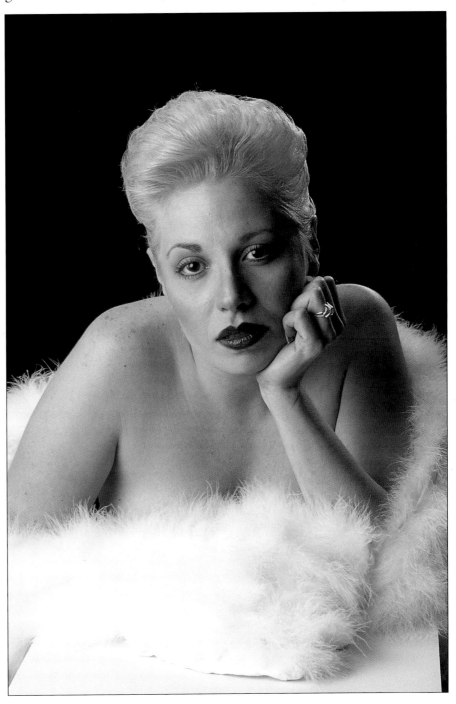

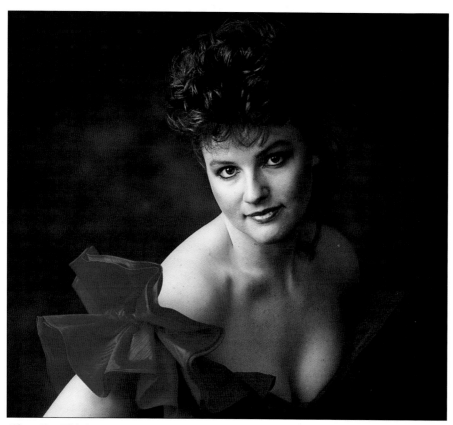

Plate 7—This is an example of a classic low key portrait. Everything except the skin tones is low key.

have touched on but also for whom you are creating the portrait and perhaps who is to be the recipient of the portrait. When the portrait is being created to hang in a home where there are a number of low key images already adorning the walls, then you will probably need to create the portrait in low key to keep the new image from looking out of place.

■ PERSONAL SATISFACTION

There is another reason many of us choose to create portraits in low key; it is a style that gives us the greatest satisfaction, and the style we are most comfortable working with when creating images.

Style. Each of us is affected differently by the tones and contrasts in images. If you are familiar with the work of Phillip Charis, then you know that it is impossible to imagine him creating images in anything other than low key. The elegance and depth of tone and the inherent mood of his portraits could not be duplicated in another key. Similarly, the superb and powerful low key portraits created by Al Gilbert would not have the same impact if created in middle or high key.

In essence, low key provides a palette on which we can shape and sculpt our subjects with panache, drama, and style that is not quite so effective in high or middle key. Working in low key allows us to create powerful images, because we can present our subjects in clear and emphatic relief from chosen backgrounds.

Exclusively Low Key. Many photographers only work in low key. The primary reason for this is that it is their personal style. They have developed techniques that have enabled them to create images that give them great satisfaction, and they don't feel the need to break out of this comfortable, emotionally rewarding style of work. For many, this is a more than adequate reason to work in low key. For others, there is a certain safe zone when working in low key. But these are not always the right reasons for making portraits in low key.

There must be a substantive reason behind the decision to create an image in a particular key. The determination should be based on the previsualization of the final portrait after analyzing the subject and deciding on what is going to be best for the client. Shrewd image creators, however, will often take the opportunity to make a creative alternate image that may be something the client is not expecting but may very well love.

*U*nless a portrait is being created in a photojournalistic style, where the attire is what the subject would normally be wearing in the chosen environment or for a particular event, clothing should be an important consideration before the portrait is made. This is just as important for on-location portrait as it is for images made in the camera room. Therefore, a clothing consultation should be a prerequisite before the style of the portrait is decided and the background and apparel are chosen.

■ GENERAL RULES

Regardless of the key that you will be working in, there are some general rules that hold true no matter the subject. Unless the portrait is made of a subject in a uniform (say a football player or cheerleader) or other such clothing where the outfit is integral to the image, you will want your subjects to avoid clothing with primary colors, stripes, checks, spots, etc. Emblems, bright decorations, patterns, or coats of arms on a shirt or sweater will become obvious in the portrait. Simple styles are always the best.

■ GROUP PORTRAITS

Many photographers will attest to the fact that clients are often inappropriately dressed for their session. This is more common when two or more subjects are to be photographed. It is important to appreciate that the majority of our subjects are not only uneducated as to what will look good in a portrait, they are also not educated in the coordination of colors and styles that will enable you to create the most pleasing images. Matching or carefully coordinating the colors and styles makes for more attractive portraits. In

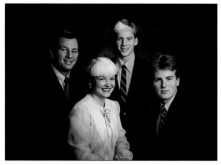

*Plate 8 (left)—This is a nice family por-
trait that could have been better with
the right choice of clothing. Plate 9
(right)—Note the difference between
the attire in this image and the clothing
choice in Plate 8. Photograph by Robert
(Bob) Summitt.*

Plate 8, the men are in dark suits and
the woman is in a starkly contrasting
color. This, together with her blond
hair, causes the woman to virtually
jump off the paper compared to the
three males.

Compare Plate 8 with Plate 9,
where the clothing of all four sub-
jects matches. This allows us to focus
on the family's faces without being
distracted by the apparel.

Simplicity. When a group of
family members is gathered from
near and far, coordinating the attire
of the subjects often represents a sig-
nificant challenge. What the family
members from Boston understand as
the photographer's advice may be
very different from the interpretation
of that advice by the family members
from Seattle. It's important, there-
fore, to confirm that everyone has
the correct information. Choosing
simple outfits can help. For example,
both indoors and outdoors, blue
jeans and blue shirts might be a good
choice—almost everyone owns these.
This clothing will work quite well on
a low key background, whether
indoors or outdoors.

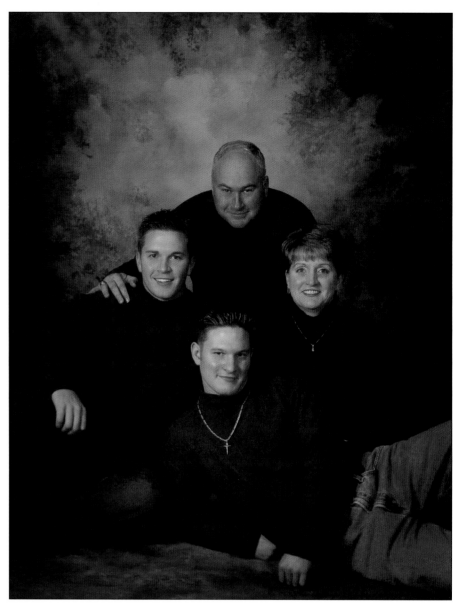

Khakis and white shirts may be
another option, especially when the
weather is particularly warm. For
indoor settings this is not the best for
a low key image, but outdoors a well-
composed group posed in these out-
fits against a green backdrop would
look very attractive and still be seen
as low key.

Subdued Colors. Generally, you
should advise clients who desire a
low key portrait to pick clothing with
subdued colors. In most situations,
the group sees the portrait as impor-
tant enough to make the slight sacri-
fice of wearing the appropriate attire

if low key is the chosen key. Should
the family still prefer to wear light
clothing, such as pastels or white,
then (depending on the size of the
group) you may have to provide a
good swath of shadowed foliage in
the background to keep the portrait
in low key. Even so, this may still
result in a clash of keys. So, in order
to maintain a low key tonal range,
subdued colors are definitely the pre-
ferred option.

Clothing in Casual Portraits.
The desire for a portrait that feels
relaxed and casual does not make it
less important to coordinate the

clothing. In Plate 10, which shows a family against a deep green background, there is no sense of matching or coordination. This presents a challenge in compositional terms and ultimately produces a somewhat confusing image. That the family may be happy with their portrait does not make it a good example of family portraiture. The portrait is simply pragmatic.

■ CLOTHING AS PART OF THE PORTRAIT STRATEGY

The clothing choices of our subjects should be considered as one of the key elements of the total composition and not in isolation or separate from all the other elements. For instance, if the client feels that a burgundy gown, sweater, or dress is her most flattering choice, and she also has middle- to dark-colored hair, then we should determine that low key is likely to be the ideal choice. In a high key portrait, the burgundy would be in stark contrast with the background. In middle key, it will be still a very striking color. Given that we would not want the burgundy to dominate the image, the subdued or darker tones of a low key background will enable us to create a more harmonious composition.

■ LIGHT-COLORED CLOTHING

As a general rule, when working in low key, clothing should be in the middle tonal range or darker—espe-

Plate 10 (top)—This total lack of clothing coordination detracts from the portrait. Plate 11 (bottom)—This style of portrait enhances the beauty of the gown, which shows it in relief against the black background.

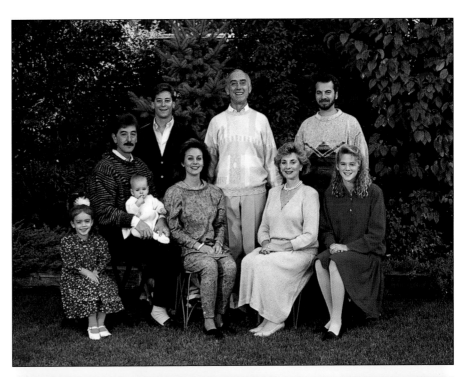

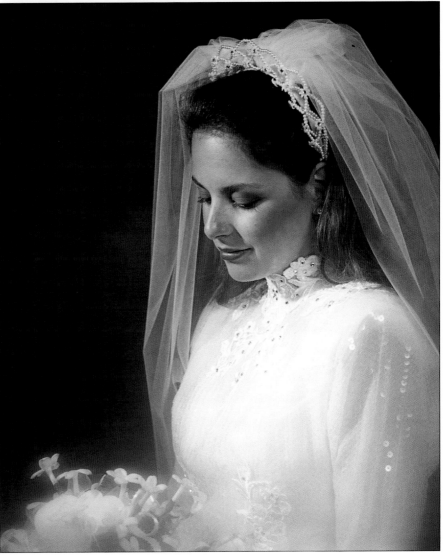

cially for portraits with head-and-shoulders through three-quarter-length poses. In such compositions, where the subject and his or her apparel fill most of the frame, lighter tones will cause the image to be in either middle or high key. This is because the overall tonal range will be brighter than 18% gray. In portraits in which there will be a substantial area of dark background included in the composition, lighter colors or tones on the subject can still be incorporated into a successful low key portrait. An obvious example is the bridal portrait seen in Plate 11.

In Plate 12, the subject's white hat and pants deliberately challenge the low key concept in the rest of the portrait. We get away with it because the hat and the pants are separated by the low key center of interest. This is an attempt to create an impression of a teenager challenging conventional attire.

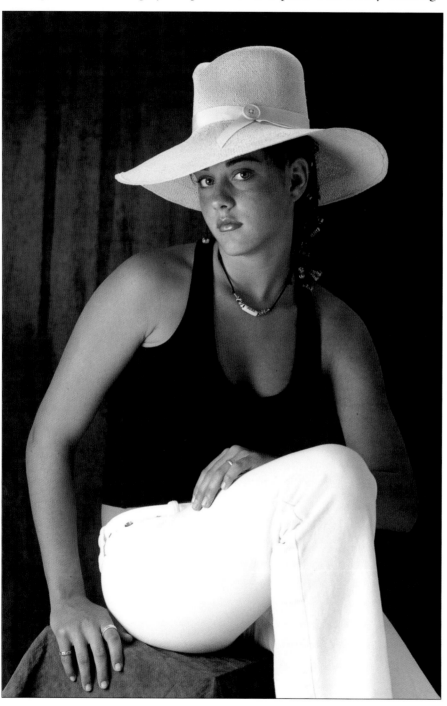

Plate 12—Teens do not always conform to convention, as is demonstrated in this portrait. The white hat and pants challenge the low key concept but the low key focal point of the portrait makes it work.

have frequently been asked by a prospective client, "What kinds of props do you have?" My first reaction to this question is to ask what is most important to them, the subject or the props? In essence, I am not a great lover of props, and I do not use props that I believe will create conflict in my images. When props are used, they should simply support the image as a secondary element within the composition; they should never compete with the subject. In Plate 13, the prop is the football, and it is an inherent part of the portrait because it tells us something about the subject.

■ COLOR

In Plate 14, we have a beautiful image of a child, but it is slightly compromised by the props (small pillars) to the left of the child—notice how they compete for your attention. These are approximately 4 stops brighter than the backdrop, and their brightness is similar to the modeling highlights on the child. Had these props been of a darker tone, they would not demand so much attention. This could have been achieved by subtractive lighting, which would have significantly reduced their brightness. The pillars are also at or near one of the power points in the composition, which makes them more eye-catching.(Power points are discussed in chapter 11.)

■ CONTRAST

In Plate 15, the beam above the subject supports the masculinity of the subject in this typically male pose. However, the dramatic contrast between the subject and the black-and-white background creates an intriguing challenge. Had the background at the right of the subject been closer in density to that on the left, the portrait would have even greater impact.

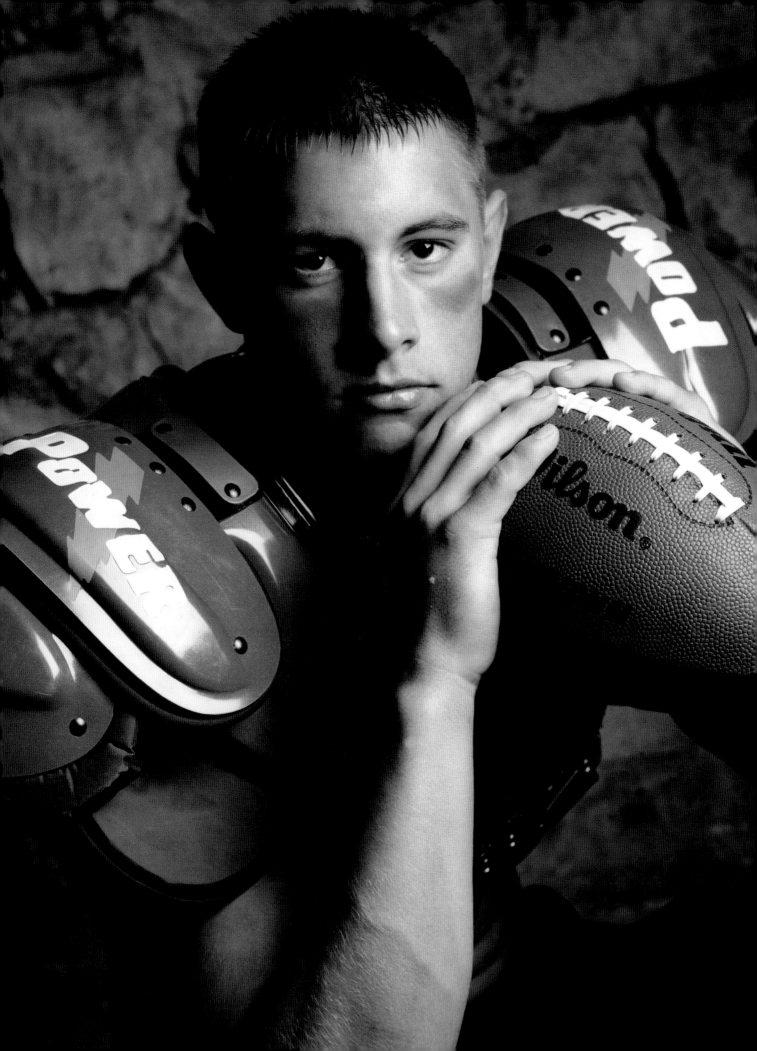

Plate 13 (facing page)—In this example the props are totally appropriate to the portrait. Photograph by Robert (Bob) Summitt. Plate 14 (top left)—Note how the miniature pillars at the left compete for your attention. Photograph by Kim and Peggy Warmolts. Plate 15 (above)—This is a great masculine pose and the props are well chosen, but the strong white tones to the right make it difficult to appreciate. Photograph by Robert (Bob) Summitt. Plate 16 (bottom left)—Note how the flowers, chair, and background support a delightful portrait of a child. Photograph by Jeff Lubin.

■ HARMONY

In Plate 16 (previous page), we see a superb example of the use of props. The wicker seat and flowers create a delicate base for the beautifully lit subject. The props are in total harmony with the backdrop.

Plate 17 is a classic demonstration of the use of light clothing and

well-chosen props. With the exception of the candle, the props are sufficiently subdued, do not demand attention, and fit the story of the portrait.

■ DESIGN

Plate 18 shows a more daring use of props. The white flowers against the dark background immediately demand attention, but because they have been used in a circular design you are brought back to the primary subject. The design would have worked a little better if the two at the

top right had been in the same tonal range as the two at the left of the portrait. Nevertheless, this is a delightful image because the total composition is skillfully balanced. When using these kinds of props, it is important to carefully consider how they will be placed. They should not just be thrown in because they seem like a good idea.

■ HIGH KEY PROPS

In Plates 19, 20, and 21, a beautiful white wicker chair is used as a key prop. In Plate 19, the chair becomes

Plate 17 (left)—Note how your attention is immediately drawn to the children and not to the props. Photograph by Kim and Peggy Warmolts. Plate 18 (below)—Using props like the flowers in this portrait requires careful placement or they will draw attention from the subject. Photograph by Jeff Lubin.

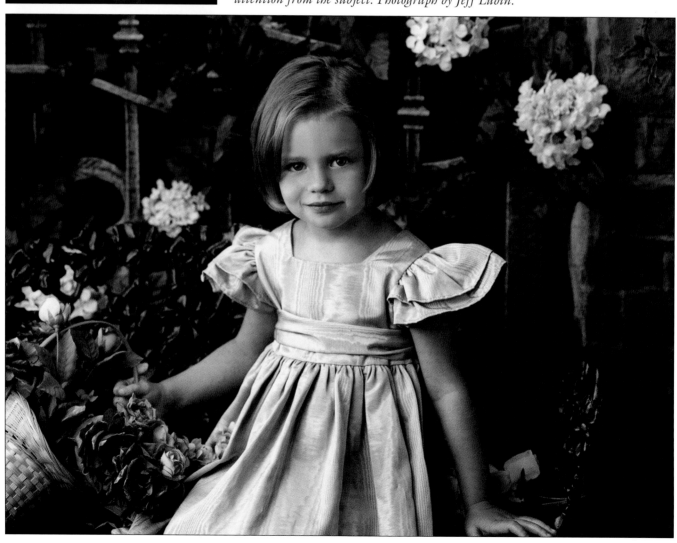

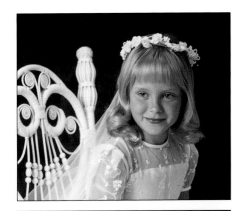

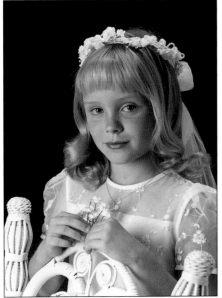

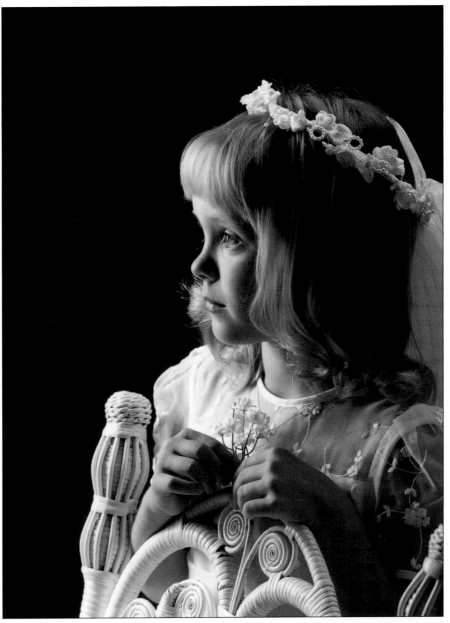

Plate 19 (top)—Note how the chair is almost a totally separate element from the subject. Plate 20 (above)—By changing the pose and positioning the chair differently, it is less of a distraction. Plate 21 (right)—After changing the angle of view and presenting a profile portrait, the chair is no longer a distraction and supports the portrait.

an element separate from the subject and is a distraction. In Plate 20, the chair is placed in front of the subject and is more a real prop than a separate element demanding attention. In Plate 21, the child is placed in a profile pose, and the chair no longer demands our attention as it is much more harmonized with the profile pose.

These latter three examples show how you can retain low key while using a white chair and white attire. Essentially, the subject is rendered in strong relief against a black back-ground. In the first example, the average brightness is approximately 1½ stops darker than 18% gray. In the second example, the average brightness is at 18% gray, and in example three the average is 2 stops darker than 18% gray. Even without these readings, the images would be regarded as low key in conventional terms because the background is black.

6.
Studio Lighting Equipment

*I*n the camera room, low key requires the use of a range of light heads and modifiers. For high key portraits, you might want to use pan reflectors and undiffused specular lighting units in order to retain bright skin tones against a white or bright background. For low key images, however, softer and less contrasty light sources are generally more suitable—except in dramatic fashion-style photography and in some male portraits. In these, the aim is often to create dynamic impact at the expense of skin tones. These images are often described as "blown out."

■ LIGHTING EQUIPMENT

Mono-heads. The preferred lighting system is one that uses mono-heads. These units are independently powered, using their own power cords that are plugged into AC outlets.

Power. The ideal units will have the facility to control the light output in increments of at least three variable f-stops. This allows you to create lighting ratios from 3:1 all the way to 4.5:1. Ratios are discussed later.

If you are on a budget, or are simply cost-conscious, you may gather heads that are not all of the same power. In this case, use your most powerful light as the main light. Your fill light can be less powerful, and the other three may be even less powerful than the fill light. However, all five lights must be capable of providing you with a level of output (measured in watt-seconds) that will meet your potential needs.

Ideally, all the units should be the same brand. This is because the watt-seconds output from each unit will be consistent throughout the system. Additionally, the quality of the light will also be consistent. This latter consideration is important, as the quality of light in your portraits is as important as the lighting patterns you will create.

Manufacturers provide the specifications for each of their lighting units. Among these specifications is the power of the unit in watt-seconds. Each manufacturer has a slightly different method of measuring this power, so these numbers are not the best guide to the output of the unit (except when the power is 500 watt-seconds or greater). The best reference, in terms of the power, is the guide number for exposure. This is based on an exposure made 10' from the unit, at an ISO of 100, using the manufacturer's standard reflector that is supplied with the unit and without any modification. Comparing these numbers allows you to qualify the equipment based on your specific needs. For example, if you wish to use f-5:6 and the unit will not dial down sufficiently, then perhaps that unit is too powerful.

As we discuss lighting techniques, you will see that you will need to reduce the power considerably to achieve some of the lighting effects. This may well be as low as 100 watt-seconds, so it is important that your light heads can be dialed down to a low power level. I do not recommend that f-stops smaller than f 9.3 be used for head-and-shoulders (or closer) portraits. (This will be covered in detail when lens selection is discussed.) While you can use a neutral density filter to reduce the intensity of the light when it is not possible to dial down the power of a unit, this has its drawbacks—including both the inconvenience of attaching the filters and the reduced control over the quality of light.

Modeling Lights. It is advisable to acquire units that provide a modeling light that adjusts simultaneously with the power of the flash. This will enable you to make visual judgments of your lighting. When your lights have this facility you will be able to see what you are going to get from your flash. More on this in chapter 15.

Kits. Some suppliers offer kits of one, two, or three mono-heads, as well as stands and standard reflectors that represent a substantial savings compared to purchasing heads individually. You can then add additional heads to the kit.

The most important thing is to make sure that the equipment you choose will meet your personal needs. Try to avoid purchasing equipment "just in case" it might be needed sometime in the future. If you already have a lighting system, it may well be that your existing equipment will provide the tools you need for the lighting techniques to be discussed, or you may simply need to acquire a few new units or the appropriate modifiers.

Modifiers. Each of the lighting units will require a modifier to soften the light. Among the most used modifiers for portraiture are umbrellas or soft boxes, which are discussed in the following section. When acquiring modifiers, it is important to remember that those used for the main light and the fill light should match in specularity or diffusion. If these two units do not have the same kind of diffusion, the lighting pattern you create will not be smooth and consistent.

If you already have light heads, you may well find that the manufacturers of your equipment also make the kind of modifiers that you will need (if you do not yet have them).

The larger photo retailers normally stock different brands of modifiers, and you should discuss your needs with your contact at the supplier or distributor.

Additionally, you will want to have a variety of other modifying accessories. These are louvers, snoots, barn doors, reflectors, and subtractive lighting panels. You will find these discussed throughout this book.

Depending on your present equipment, speed rings that permit you to attach the modifiers may be required. Most manufacturers, aware of the many options you have when purchasing lighting equipment, provide a wide variety of speed rings.

■ FIVE-LIGHT SYSTEM

Considering the wide variety of styles and lighting patterns you may choose to use, as many as five lighting units may be required for any given portrait. My recommendations are as follows.

Main Light. There are two preferred options for this light: a soft box or an umbrella. For the main light, you should use your highest-powered mono-head. Because this is the light that will create your primary modeling in the setup it will need to provide the most power.

Umbrellas. Umbrellas are a popular and very versatile modifier for the main light. However, they also require great skill to control, as they tend to throw light over a wide area (as compared to a soft box). Please see Diagram 1 (next page). Umbrellas, in general, are also less expensive than soft boxes—at least until you get into the mega-sized models, such as the 60" type.

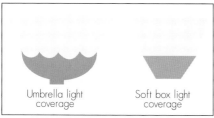

Diagram 1

Many photographers prefer umbrellas because they provide a circular catchlight in the eyes of the subject, while soft boxes (without the use of a circular modifier) provide a rectangular or square catchlight. The square catchlight is most obvious when the subject is photographed close up.

A uniquely effective umbrella-style modifier is the Halo, made by FJ Westcott. This is an umbrella with a front diffuser that is shaped like an umbrella in reverse. A useful aspect of this modifier is that it provides a falloff of up to 25% at its outside edge, which creates a gentle form of vignette (see Diagram 2). Other umbrella manufacturers also provide attachments for the front of their umbrellas that assist in controlling the coverage of the light. For example, some umbrellas are available with a small disk-shaped attachment that is placed in front of the flash tube and effectively reduces the hot

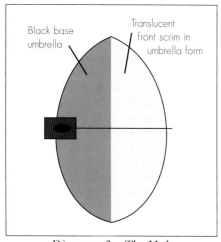

Diagram 2—The Halo

spot produced by the flash tube. This creates a more even light source.

If you choose to use an umbrella system, you can innovate with other forms of light control. This may be as simple as placing a black strip of fabric (or other material) over part of the umbrella. An effective method of creating a vignetted light source is to place an additional modifier on the front of the umbrella. This additional modifier is referred to as a scrim and covers only the outer area of the umbrella. This allows the desired exposure from the center of the light, while reducing the exposure at the outer edges of the umbrella. This scrim should be of a semi-opaque material that will inhibit up to 50% of the light power emitted from the umbrella. See Diagram 3.

Diagram 3

Soft Boxes. Soft boxes come in a wide range of sizes from 16" square to 72"x48". There is also the unique Octabank model, made by F. J. Westcott, which has a diameter of 72". This is an excellent modifier if you have a large area in which to work and want to create a realistic daylight effect. Other large soft boxes will provide similar effects.

If you choose to use a soft box, you will will have several options for attachments that can be used to con-

trol the coverage of the light. These are: black strips, louvers, and black panels of material with circular openings (providing circular catchlights). When you attach a louver to the front of a soft box you will increase your control of the light because the attachment enables you to focus the light on your subject and significantly reduces the area of coverage. See Diagram 4.

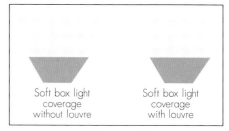

Diagram 4

Fill Light. The fill light will create the light ratio (the exposure difference between the highlight and shadow sides of the face) you choose for the portrait.

Modifiers. As a general rule, the fill light unit and its modifier will match the main light and its modifier. However, fill lighting can be achieved in ways that might be considered unconventional or "creative." If you have chosen to use a soft box as your main light, you may still use an umbrella light as a fill. Alternately, you could choose to use bounced light as fill. Keep in mind, however, that the light from both of these sources will be more difficult to control.

While the potential for fill light spilling into areas of the image and breaking down the modeling created by your main light is relatively remote, there are some cases where this can cause problems. For example, if you are seeking to isolate the subject from the background and do

not want more than a hint of the background's texture to show, you will want to have good control of the fill light and avoid spill. In this case, you will definitely need to use a modifier that enables you to focus the fill light onto only the areas of the image that you want it to fill.

An excellent method of producing fill light is demonstrated in Diagram 9 on page 46. In this setup, a 24"x72" reflector or diffused light unit is placed behind the camera. This fill source is most often placed high on the rear wall of the camera room.

Reflectors. While photographers rarely use reflectors as fill lights in the camera room, there are still some cases where reflectors are the ideal tool. Therefore, having a selection of reflectors is very useful. The most advantageous reflector to have in your arsenal is the type that comes with soft white on one side and silver on the other. This reflector will allow you to match your reflected fill light to that of the main light (when this is desirable).

Reflectors are available in numerous sizes and configurations. Among the most popular are those that open into large disks, then fold up and fit into small circular carrying bags for easy storage. This also makes them easy to take along on location shoots. Most of these reflectors have a loop that allows you to hook them onto a tripod or light stand for convenience. Many photographers make their own reflectors out of aluminum and white card or fabric. If you are a handy person you might choose this option.

Reflectors enable you to add fill light from the front of the subject and also from behind and below the subject—useful when the subject is in very dark clothing and you need to balance your lighting for greater all-around illumination. Carefully placed reflectors can add the additional lighting enhancements that make your portraits glow.

Hair Light. The unit you decide to use as your hair light should provide good control. Otherwise, you will spill unwanted light all over your set. Snoot modifiers are good tools for both the hair light and kicker lights. A snoot allows you to focus your light on the hair without illuminating any other area of the subject or set.

A soft box with a louver accessory also makes a good hair light, as it will prevent the light from falling onto areas that do not require lighting. As you will have noted in Diagram 1 (facing page), even without a louver, a softbox offers more control than an umbrella. As noted in Diagram 4 (facing page) the addition of a louver yields even more control.

There are additional methods of producing light on the hair without using a separate hair light. These are covered in chapter 7.

Kicker Light. As noted above, the snoot is an excellent light modifier when you need a focused kicker light. This modifier will allow you to light a limited area of the subject in order to create a greater appearance of dimension, or simply to create a rim of light for greater separation of the subject from the background. Some snoot attachments have a slot into which you may place a diffuser or other enhancing accessory.

Background Light. The background light can be a focused mono-spot, a snoot, or a low-power unit that is placed on a small stand behind the subject. The mono-spot and snoot are very useful when you are photographing one, two, or three subjects in a group.

The use of the above lighting units and their modifiers is adequate for all but the most complex portrait lighting setups. If you want to be proficient at advanced and complex lighting systems, then you can acquire additional lighting units, such as mini-spots, which are also available with their own barn doors. These will allow you to become intricately involved in enhanced lighting systems that go beyond traditional portraiture techniques.

7.
Basic Studio Lighting

There are some lighting techniques for low key portraiture that have proved to be successful since portrait photography entered the modern era. Many of them have grown out of the old styles of the 1930s and '40s—styles that were popular and recognizable because they were used on movie stars. As pioneers of modern portraiture, masters such as Al Gilbert, Monte Zucker, Bill Macintosh, and Philip Charis (among others) have added to this list of techniques. Although their styles are different, each has added something to the lighting arsenal that so many photographers use. The real test, however, is to learn lighting from a personal perspective. No matter how accomplished the artist, simply copying the systems used by others will limit your ability to create uniquely different portraits.

■ VARIATIONS

Lighting is subjective; it should not be dictated by locked-in patterns. While these setups are fine for one-hour studios that need fast and consistent lighting systems, if you use one unchanging lighting system for your portraits you will become bored with your images and your work will become mundane. Professional-quality portraiture requires you to creatively apply learned knowledge and an appreciation of what light can do for you. So don't tape down your lighting units—be ready to move them to fine-tune your images.

In Plates 22–26, simple but fundamental lighting techniques are used to create a progressively enhanced full-length portrait.

In Plate 22, only the key or main light is used. This creates a very long and unflattering light ratio of 5:1. The heavy shadow from the nose is indelicate and does not suit the subject.

In Plate 23, a fill light (1 stop less bright than the main light) and a hair light (equal power to the main light) are added. These soften the nose shad-

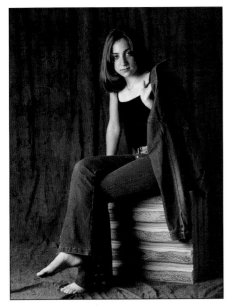

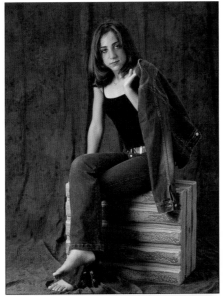

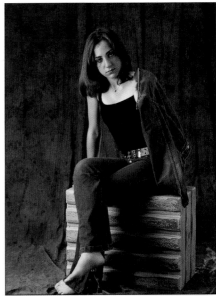

Plates 22, 23, 24 (top row, left to right), 25, 26 (bottom row, left to right)—Note the subtle but important lighting changes in each image in this sequence and how they change the viewer's impression of the subject.

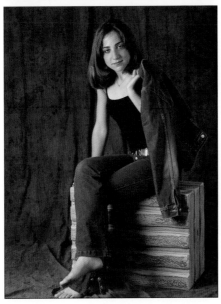

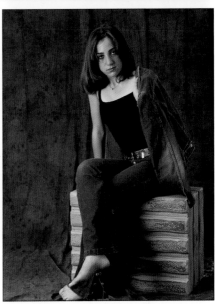

ow and create separation between the subject and the background.

In Plate 24, the fill light is reduced by ½ stop, which creates a more dramatic rendering of the shadow side of the face. Additionally, a kicker light has been added that enhances the sense of depth and roundness to the subject's arm. It also increases the dramatic effect of the portrait.

In Plate 25, the kicker has been taken out and the hair light has been reduced by ½ stop—but the fill light has also been increased by ½ stop. The effect is that the dramatic

impression of Plate 24 has been reduced. The more open lighting on the subject's face makes her appear softer and gentler.

In Plate 26, the kicker light is brought in and the hair light returned to the same power as in Plate 23. Additionally, the fill light has been reduced by ½ stop. The overall effect is a compromise between Plates 24 and 25.

Additionally, note that the camera position has been adjusted slightly in each of the images. Doing so creates a different perspective in each. Perspective is an important ele-

ment in portraiture. Each time you make an adjustment in lighting, you can create more interesting choices by changing the camera angle. It is another way in which you create greater interest in your images.

■ ONE LIGHT AT A TIME

These are very simple techniques by which you can change the impression of your portraits. But the real key to successful low key lighting is mastering the use of one light at a time.

In Plate 27, only one light was used. This is a type of soft box called a Mistylight (by Bowen's), and has

Plate 27—This is an example of a portrait created with a single, very soft light.

an 18% gray interior plus two diffusing scrims—one at the front of the box, and one between the front scrim and the flash tube. The light produced by this unit is very soft and needs to be used within its optimum quality of light range (see sidebar).

By carefully positioning this light unit, the subject is illuminated on both sides of the face and the hair. For this image, the box was placed at approximately a 45° angle to both the camera and the subject. It was roughly 12" above the subject's head and tilted down about 15° toward the subject. This causes the box to act as a main, fill, and hair light (see Diagram 5a and Diagram 5b).

Depending on the particular circumstances, a reflector could also be introduced on the shadow side of the face to create a shorter ratio. Should this be desirable, the reflector will need to be made of a white material (not silver) and placed very close to the subject, since the softness of the main light means that it will not create a significant amount of reflective light.

If you practice this form of lighting technique you will find that your overall lighting skills will be significantly enhanced. Practicing this technique allows you to see the subtleties of single light portraiture. It is not dissimilar to using window light, which will be covered in chapter 9.

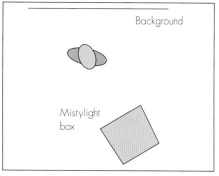

Diagram 5a

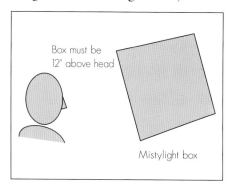

Diagram 5b

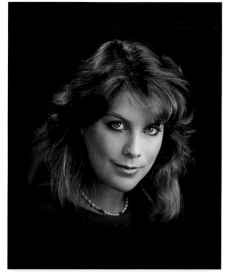

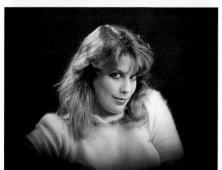

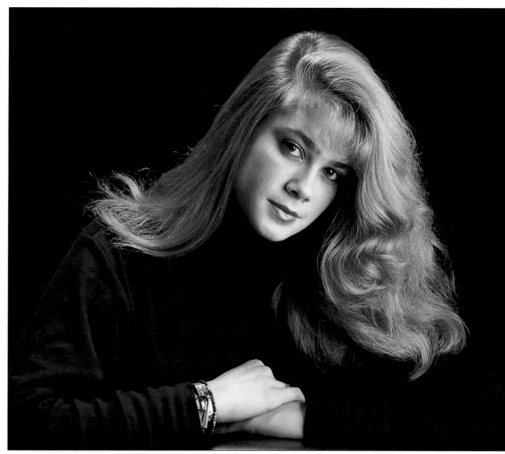

Plate 28 (top left)—This soft light was brought in close to use its optimum quality to model the face. The snoot modifier keeps the hair in balance with the main light. Plate 29 (bottom left)—Compare the greater intensity of the hair light in this image to that in Plate 28 and note how it brings the overall brightness into balance. Plate 30 (right)—Moving the hair light immediately overhead created a more mysterious look in the eyes and modeled the face in an unusual way.

■ LIGHT POSITIONS

Plates 28–30 demonstrate how slight changes in the position of your lights can create different impressions. They are examples of the subtleties of lighting techniques that can add dimension to your portrait work. The important thing is to recognize the difference in each example and commit them to memory so they may be used when they are most appropriate.

In Plate 28, the Mistylight was used again for the main light. A snoot modifier was used as a hair light from behind the head of the subject. The exposure of the hair light was matched to that of the main light, so that the illumination of the

subject's hair was evenly balanced, and the portrait, made against a black background, has almost a three-dimensional appearance. The position of the hair light was critical in this portrait; having it directly overhead would have overlit the hair. See Diagram 6.

In Plate 29, a stronger hair light was deliberately used to balance the subject's white sweater. When photographing in low key (in this instance against a virtually black background), white or very bright clothing can be better balanced by increasing the power of the hair light in this way.

In Plate 30, the hair light was brought more directly over the subject's head and created a different

style of lighting pattern on the face. Note how this slightly different hairlight position keys onto her cheekbones, creating a more dramatic impression of a beautiful face with slightly deeper-set eyes. The effect is to create a slight mystery in the eyes.

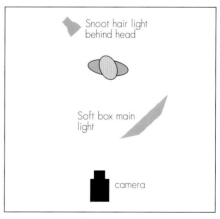

Diagram 6

Snoot hair light behind head

Soft box main light

camera

■ INTRODUCING ADDITIONAL LIGHTS

Producing portraits with a dramatic, dynamic, almost three-dimensional look against a black background means you will need to use additional lighting units. For Plate 31, a fourth light (in addition to the main, fill, and hair lights) was introduced at the side and slightly to the rear of the subject.

The subject, a platinum blond, was wearing a Russian-style velvet headband that allowed her hair to show above the band then fall behind her head. She was resting her cheek against a black coat that matched the black background, and her bare shoulder was positioned to create a provocative look.

For this portrait, the main light was placed at a 40° angle to the subject and from the side of the black coat to create a dramatic contrast between the subject's face, the black coat, and the headband. The output of the fill light, a 30" white umbrella, was deliberately reduced in order to create a 4:1 ratio against the subject's dramatically lit hair and shoulder. The hair light was a silver mini-umbrella. The sidelight (which you might describe as a kicker light) was a snoot, which provides good control. See Diagram 7.

The result is a stunning and provocative portrait, which was made for the subject's husband. It is more than a glamour shot; it's dynamic. It is a style of portrait that is most unusual.

■ DRAMATIC EFFECTS

A dramatic lighting effect is demonstrated in Plate 32, a portrait of two boys. If you have practiced observing

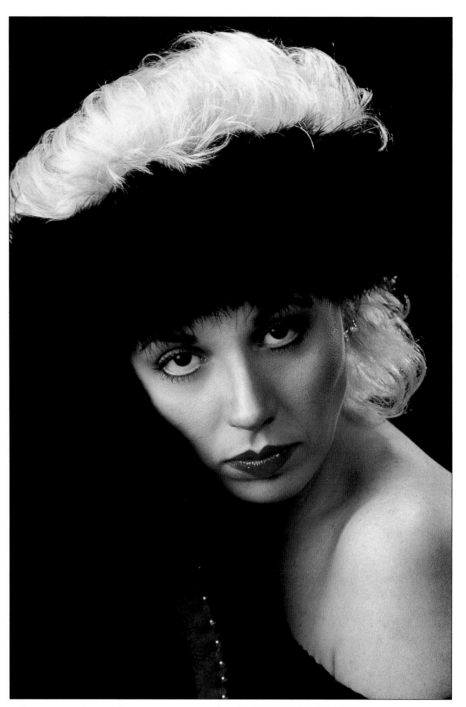

Plate 31—The addition of a fourth light slightly behind the subject created a more provocative look.

light you will notice that the light is from the left and positioned so as to virtually split the lighting (i.e., the shadow side of the face is very dark and without much modeling). This is a technique that can be used to create a pensive and questioning mood in the portrait.

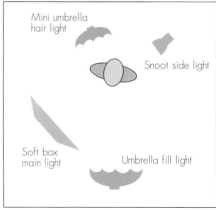

Diagram 7

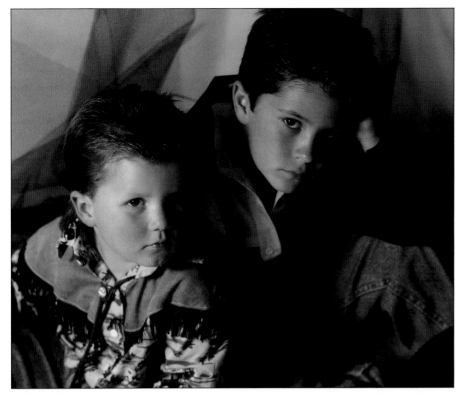

Plate 32 (left)—Turning the faces causes a split-light lighting pattern that can be used to create mood and attitude. Photograph by Dennis Craft. Plate 33 (right)—Here, the mood is very different from in Plate 32 because the child's head is not turned so far away from the light. This creates a more dreamy look because there is a catchlight in each eye. Photograph by Jeff Lubin.

Notice how the shadow sides of the children's faces display patterns that we normally would not recommend in a conventional portrait. There is a catchlight in only one eye of each subject, and although there is not a catchlight in the eyes on the shadow sides, there is enough detail to soften the 5:1 ratio. Because the photographer has set out to create a "mood" image, the fact that he has broken a recognized rule is readily forgiven because the portrait is very effective. Knowing the "rules" means when you break them there is purpose and effect.

Plate 33 presents a totally different take on the technique used in Plate 32. Here, the photographer positioned the subjects, attired in black, in an interactive relationship so that the lighting on each subject is distinctly different.

You will also note that the light is from the left, as it was in Plate 32, but here the child is turned less away from the light so the lighting ratio between the main light and the fill light is 3:1. This also means that the lighting on the man is flatter by comparison—even though the photographer used a hair light that picks up the back of the man's neck and ear. It is a daring portrait because retaining harmony in this type of image is much more difficult than simply creating a conventional portrait.

■ INDIVIDUALIZED PORTRAITS

Creating different impressions of your subjects is the key to successful portraiture. Each subject deserves individual attention so that each portrait is unique—not, as a colleague describes some formulaic images, "Kentucky Fried Portraits." Plate 34

has a totally different feel than any of the others so far shown. This is a simple three-light set of main light, fill light, and hair light. The lights were set to create a 3:1 ratio and a #3 soft focus filter was added to lend a touch

Plate 34—A thoughtful mood and soft lighting, combined with soft focus, created an intriguing portrait.

Plate 35 (left)—Note how the kicker light created a slightly chiseled sculpturing of the face, which works better for male subjects than for females. Plate 36 (right)—The slightly longer ratio between highlight and shadow sides in this portrait dramatizes the beautiful dark eyes and hair of these young ladies. The hair light intensity was calculated to hold their natural hair color.

of mystery to the portrait. Soft focus is different from diffusion, which is covered in detail in chapter 12.

For this portrait, the subject was wearing a white hat and her blouse was off-white—something of a challenge. The light tone of the hat required the hair light to be a little less intense to avoid burning out the texture in the hat and creating too much contrast between it and the rest of the image. This adjustment of the hair-light power is an important element in the rendering of the portrait. When this is not taken into consideration, your images will not be quite what they could be. The importance of minor lighting adjustments cannot be overemphasized as a factor in creating quality portraits.

■ LOW KEY SENIOR PORTRAIT

Plate 35 is high-school senior portrait made in a traditional style that has been largely abandoned by photographers seeking to make teenagers happy with fashionable senior por-

trait styles. It is in dramatic contrast to Plate 15, which is also a senior portrait.

The background in this portrait is composed of deep reds and browns with a touch of pink that creates a softer feel than the really dark backgrounds shown earlier. It is better suited to the personality of the subject. A kicker light has been added to the shadow side of the face to provide a little sizzle to the portrait. The kicker light also creates a slightly more chiseled sculpturing of the face. Other than the kicker light, the rest of the lighting setup is comprised of the traditional main, fill, and hair light, set to produce a ratio that is slightly longer than 3:1. This slight lengthening of the ratio from a basic 3:1 was created by dialing down the fill-light a little less than ½ stop. There is no written or unwritten rule that says you have to create ratios in half or full stops. Your adjustments should be based on the end result you are seeking.

■ HAIR

Lots of dark hair can be a challenge for the photographer. Lighting the hair while maintaining a balance with the subject's skin tones requires an accurate exposure. Otherwise, the color of the hair will not be properly represented.

Plate 36 is a portrait of two young ladies with lots of exotic dark hair, dark brown eyes, and beautiful skin. This type of portrait requires the hair light to be very carefully calculated. It is very easy to misrepresent a subject's hair color by using either too much or too little light. As a rule of thumb, your hair light should match your key light, but this is just a starting point—adjustments must be made for each subject.

For black hair, the hair light should generally be set approximately ⅓ stop less than the main light. Otherwise, you may find that you have lightened the hair too much. For blond hair, set the hair light about ½ stop higher than the main

light, or you may find that the hair looks duller than it really is. These are guidelines, but the trained eye will be able to see that the light is either too strong or not strong enough. As you evaluate the hair light, make sure that your modeling lights are matched to the power of the light you are using, so that what you see is what you get.

In the case of Plate 36, a longer ratio was used to assist in rendering the hair its true color and maintaining the beauty of the subjects. It is another example of matching the lighting set to the subjects and not using a set lighting pattern.

■ THE EYES

With Hats. The challenge in Plate 37, classic low key style portrait, was to light the eyes below the hat, which is black and shrouds the subject's forehead. This requires that the main light to be placed accurately so that it will not break down the lighting pattern modeling the face. A common mistake when attempting to achieve this objective is to tilt the main light up into the face from too oblique an angle. This creates a too strong light from below and does not render the jawline kindly.

The goal is better achieved by slightly tilting the main light downward, approximately 10°. This maintains the jawline as it should be rendered and also lights the eyes and forehead, as seen in this portrait. Here, the main light has also been slightly feathered so as not to make the child's hand appear too bright. Please see Diagram 8a and Diagram 8b. To create an even more interesting portrait, a texture screen has been added.

A double scrim soft box with an 18% gray interior was used as the main light for Plate 37. When photographing blacks, especially velvet and similar materials, a soft light source like this will help to render detail that a harder light will eliminate due to the resulting increase in contrast. A hair light was also added to the setup to pick up the edge of the girl's hat. A mono-spot was then directed onto the background to create separation, and a fill light was used to shorten the light ratio in order to present a soft rendering of the subject's skin tones.

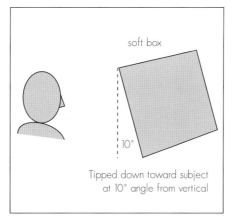

Diagram 8a

Diagram 8b

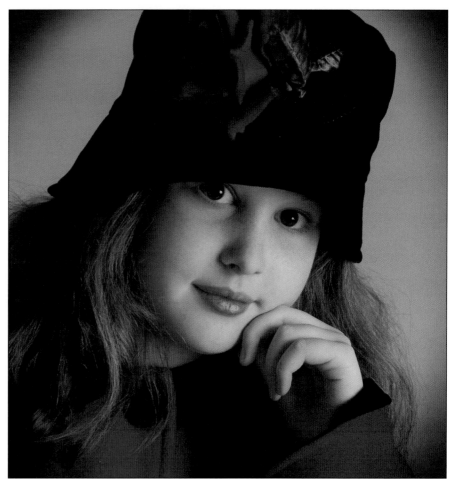

Plate 37—Accurate placement of the main light is critical to successfully lighting the eyes while maintaining the correct lighting pattern on the face.

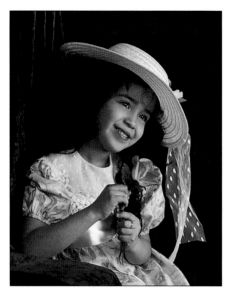

Plate 38 (above)—In this portrait, the placement of the main light was more conventional. The hair light was used to transmit light through the hat to provide a little more illumination on her forehead. Plate 39 (right)—Note how the lens perspective causes you to be totally engaged with the young lady's eyes—the soul of the portrait. The tight loop lighting pattern of her nose is perfect for this portrait. Photography by Robert (Bob) Summitt.

In Plate 38, the placement of the main light is as accurate as in Plate 37. As a result, you can see the slightly less well-lit forehead of the child. The hair light was increased slightly so that some light filtered through the white hat and added to the illumination of her face. This is an example of observing the effect of the light and being aware of how it may transmit through the fabric of the hat.

Perspective. In Plate 39, the photographer decided to allow the hair to fall away from the primary lighting pattern. At the left of the face, the hair has fallen into relative shadow. This effect is successful in this portrait because the lighting is soft and gently wraps around the full-face view of the young lady. The softness of the light is mirrored in her eyes, as the catchlights are also soft and gentle. Had the photographer used a harder light source, the hair (because it was not lit separately) would have fallen too deeply into shadow and would not have separated from the background. The softness of the light and the perspective of the lens combine to engage the viewer with the young lady's eyes. The eyes are the soul of this portrait, and this is an excellent example of soft lighting in a head-and-shoulders portrait.

■ MASCULINE VS. FEMININE LIGHTING STYLES

Masculine. The lighting pattern in Plate 40 was designed to create a strong, masculine look. Lighting two subjects requires you to feather your main light so that it will equally illuminate both subjects with the same lighting pattern. Here, you will note that the slightly hard light from the left creates dimension in the facial modeling and is enhanced by a nice balance of fill light. The effect is a portrait that shows character and

depth of tones. The placement of the figures is so well done that the main light is able to evenly illuminate both subjects. A background light created separation between the subjects and the backdrop.

Feminine. Compare the lighting in Plate 40 to that in Plate 39 and you can see that, in general, there are different approaches to female and male portrait lighting. In Plate 41, however, a different approach has been used to capture the flamboyant personality of the female subject. The lady had a high-profile reputation as someone with an exuberant personality and a somewhat exotic clothing style that she used to promote her charity drives. The blues in the background complement her attire and adequate light has been directed onto it so that it stays in low key but retains its vibrancy.

■ MOOD

Mood is an important element in portraiture. Our body language and our eyes transmit our mood. Our eyes tell the way we feel better than any other form of messaging. In Plate 42, the photographer has captured mood by using a simple lighting setup with a soft main light placed slightly off camera to his right. Looking at the second catchlight in the subject's shadowed eye, you can also detect a fill light. The melodramatic moodiness of the image is enhanced by the slim cropping, which draws the viewer immediately to the girl's eyes.

This is a classic example of a low key portrait that was created without using a backdrop yet is nonetheless low key. Such simple styles of portraiture are used rarely because portrait

photographers tend to embrace more complicated lighting sets. Here, however, it's the simplicity that makes the image so successful.

■ SOFTNESS AND SKIN TONES

Plates 43–45 (next page) are beautiful examples of soft lighting techniques that render exquisite skin tones. Soft lighting is perfect for mother-and-baby portraits, and produces prints that will translate exquisitely into black & white or toned prints. These images also

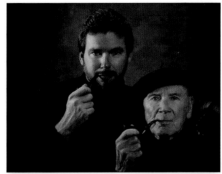

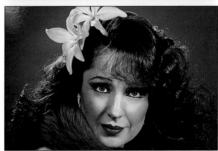

Plate 40 (top)—This portrait is an example of how to create a character impression and a feeling of depth by directing the main light from a sharper angle. Photograph by Kim and Peggy Warmolts. Plate 41 (above)—This style of lighting is designed to match the flamboyant character and personality of a woman well known for her extroverted personality. Plate 42 (right)— The simplicity of this portrait is what makes it so successful. Photograph by Robert (Bob) Summitt.

demonstrate how to position your subjects against muted backgrounds so as to create separation without excessive contrast.

The lighting in these images is so well controlled that only a trained eye can guess what kind of lighting was used. Great lighting technique will always keep you guessing, because it is not obvious.

In Plate 43, a soft box was used at a 45° angle from both camera and subject. You can see this by examining the lighting pattern, a slight loop

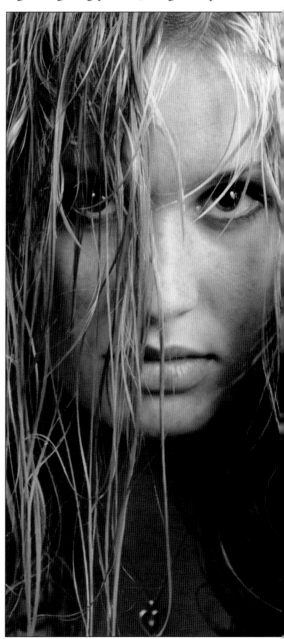

lighting below each subject's nose. Note also how the light reflects off the mother's arm and shoulder and reduces the lighting ratio on the baby's face to 2.5:1 (compared to the 3:1 ratio on the mother's face). This control of the fill light ensured that the delicate skin tones are maintained. Had the fill light been any brighter, it would have changed the delicate rendering, which is enhanced by slight diffusion.

A gentle vignette reduces the potential eye-catching contrast of the baby's foot against the darker area at the bottom of portrait. This is a very important concern when working with low key, as you need to avoid distracting elements at the outside edges of your portraits.

Notice how the subjects have been placed against the backdrop. The highlight side of the subjects is against the basic dark area, while the shadow side is against an area that is brighter. This balances the overall tonal representation.

In Plate 44, the photographer has used a much more frontal main light, and you will note that the modeling of the subjects is much less dramatic—in fact, it is almost flat. This is revealed by the altogether soft rendering of both the mother's and baby's features. The lighting is so soft that the only hard shadows occur in places where the subjects are touching each other. The positioning of the subjects against the backdrop is similar to that seen in Plate 43, but this time the contrast is much lower.

In Plate 45, the photographer moved the soft box farther to the left of the subjects than in the other two examples. This is revealed by the shadows below the baby's chin, the beautiful light on the mother's profile, and the shadow at her back. The outlining on the nape of her neck also emphasizes this.

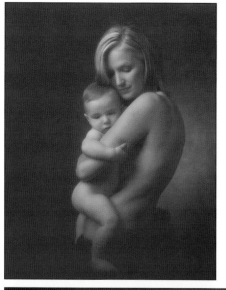
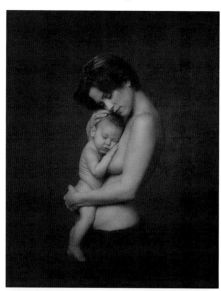

Plates 43 (top left), 44 (top right), 45 (bottom)—The delicacy and harmony of tonality and lighting in these three portraits is absolutely delightful. They are great examples of how to balance the focus of the portrait with the selection of background and lighting style. They are wonderful examples of mother and baby portraits. Photographs by Edda Taylor.

*I*n Plate 45 (facing page), you saw how the photographer created a delightful profile portrait of a mother and baby. To achieve this level of profile lighting, you need to have excellent control of the main light.

This may be achieved by using a narrow soft box (called a strip box) or a louver attachment that will ensure that light does not spill into areas of the image and compromise the intended light pattern. The control displayed in Plate 45 is excellent, as the main light has not spilled onto the backdrop.

Often, if the main light is sufficiently soft, a fill light may not be needed since truly soft light wraps around the gentle curves of the human form. In Plate 45, the fill comes either from some reflected light or a light set to less than $\frac{1}{2}$ stop; it is barely perceptible.

■ TWO SUBJECTS

In Plate 46 (next page), the photographer was challenged by the task of creating a profile portrait of two subjects together.

Posing. Placing two subjects in a profile position must be done carefully, since both must show just an eyelash on the far side of the face for it to be a genuine profile. You should not be able to see the eye on the far side, and there should be no other flesh tones visible beyond the outline of the profiled faces.

Light Size. When lighting two subjects, the lights must be placed so that neither subject causes a visible shadow to fall onto the other. This means that the width of the light modifier needs to be adequate to light both (if it is too narrow, the figure nearest the camera will not be illuminated properly), but not so wide that it over-lights the subject nearest to the camera.

In this portrait, the normal choice would be a light box with a front width of 16", yet the photographer actually used a 36" soft box at f-11 and

In this portrait, the lighting pattern was achieved by placing the main light slightly behind the plane of the subjects so that the light is directed slightly toward the camera. Approximately ½ stop of fill light was added—just enough to open up the face of the woman and show her delicate jawline. The use of a vignette at the bottom right subdues the bright dress and helps draw your attention to the subjects. Diagram 9 shows the lighting set for this portrait and shows that a spot with a grid modifier was used to create separation from the background.

■ CANDLELIGHT PORTRAIT

Main Light Modifier. Plate 47 is a storytelling profile portrait designed to create the impression of a young boy reading by candlelight. This required optimum control of the main light; otherwise, excess light within the set would have destroyed the candlelight effect. Here, the modifier on the main light was a snoot with a semi-opaque diffuser at the front. Without the diffuser, the light would have been too specular and created an intense shadow on the camera side of the face. This would have required an inappropriately intense fill light. Adding the diffuser made the light look much more like candlelight, which is not as soft as a soft box but still is able to wrap around the face slightly.

Main Light Power and Placement. In this portrait, it was important to balance the power of the main light with the required exposure needed to capture the lighted candle as realistically as possible. Additionally, the position of the main light had to be just right or it

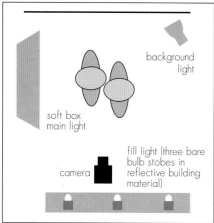

Plate 46—In a profile portrait that shows the subjects in a harmonious mind-set, the point at which the couple is focusing is the key to creating the mood. Photograph by Kim and Peggy Warmolts. See Diagram 9 (left).

still produced a beautiful profile. Because it produces a narrower field of light, a 16" soft box at f-11 would have produced a longer light ratio than the 36" box. It would also have required that the fill light be set at f-6.3 in order to achieve the same rendering of the woman's face.

Light Placement. Often, when creating profile portraits, the main light is misplaced and used directly in front of the subject. If you do this, you will find that the modeling of the face in front of the camera will be too bright, and the face will appear to be deeper from the nose to the ear than

it actually is. In most cases, you will want your profile to have a strong outline at the front mask of the face and have a longer ratio between the highlight and shadow area.

You will note that the lighting in this portrait accentuates the noses of both subjects at the far left of the face. The light then falls off as it travels toward the ears. In this instance, the light ratio is 3:1 on the woman and 3.5:1 on the man. This relatively short ratio for a profile works well for a subject like this pretty woman, but may be too short for a dramatic profile of a male subject alone.

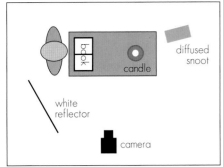

Plate 47—To create this portrait, special care had to be taken to match the main light with that of the candle. Otherwise, the light on the boy's face would not look like candlelight. See Diagram 10 (above).

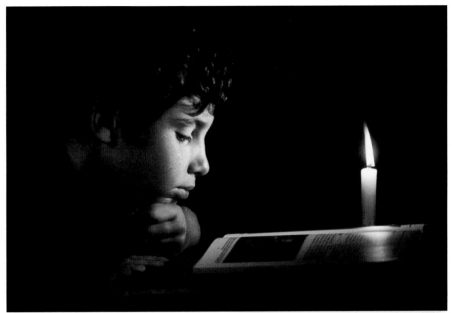

would have illuminated the child in a way that candlelight could not.

Fill Light. The final touch is the very subtle fill light. A white reflector was placed parallel with the back of the child's head and angled slightly toward his ear so as to produce the equivalent of ⅛ stop of light on the camera side of the face. The final image is quite realistic and appears as if it was in fact exposed by candlelight. See Diagram 10.

■ RED HAIR

Both the lighting and composition in Plate 48 were designed to use the young lady's hair and the black background as a base. To take advantage of these two elements, a two-light set and a reflector were used. The main light was a 36" white umbrella placed slightly behind the plane of the subject to illuminate her hair and face and, at the same time, create a dark area on her hair to support the facial modeling. The hair light was a barebulb strobe with a snoot modifier set high in front of the subject. A white reflector was placed immediately behind the subject. This produced just enough illumination to

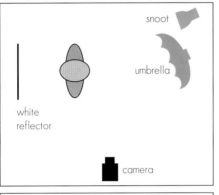

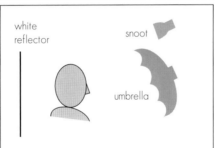

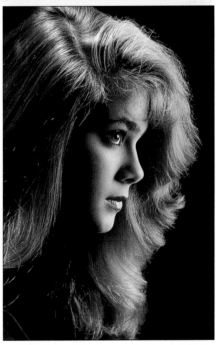

Plate 48 (right)—The focus of this portrait is the contrast between the face and the shadow area on her hair. This contrast, and that between the hair and the black background, creates exceptional impact. See Diagram 11a (top left) for a bird's eye view of the lighting set, and 11b (bottom left) for a camera view.

prevent the hair from appearing black. Both lights were of equal power, so that the beautiful red hair is in balance all around the profile. See Diagram 11a and Diagram11b.

■ LIGHT CLOTHING

Plate 49 is an example of a classic profile of a white-clothed subject

against a very low key backdrop. Because the portrait commemorates a child's first communion, the main light's 4:1 ratio was softened by the use of a fill light modified with a Westcott Halo-Mono. This was bounced off the wall behind the child and at a position slightly closer to the camera than the child. The

Plate 49—This portrait was used to illustrate another technique earlier. The key light was placed so you see a side view of a perfect loop pattern around the nose. See Diagram 12 (above).

hair light, aided by the fill light, almost exactly matches the exposure of the main light and retains the natural color of her hair.

Main Light. The main light was placed behind the plane of the subject and turned toward her to create a perfect loop shadow around the nose. This yielded perfect rim light on the profile while creating only a gentle shadow through the depth of her face. A soft box was used with just the front modifying scrim and a black strip was attached to it to reduce the width of the light source.

Props. As was previously noted, the way that the white chair was used is quite important. For this low key portrait, it was important that the chair not become a distraction against the dark backdrop. Therefore, the child was placed so that her

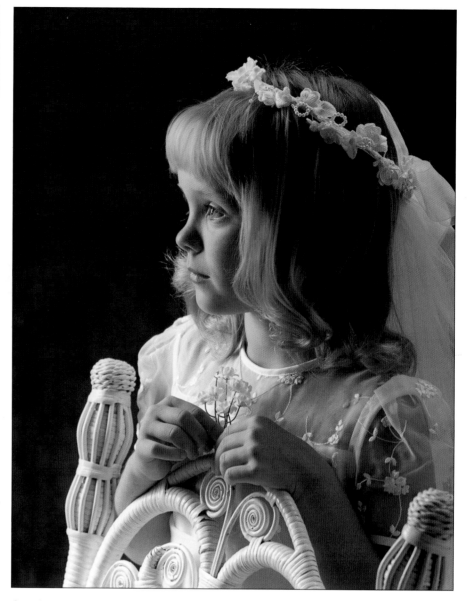

far shoulder was very close to the chair, closing the potential gap between her and the chair back. Her hands were placed on the back of the chair, providing a low key element between her dress and the back of the chair. This is achieved by the 5:1 ratio on her fingers and the arm closest to the camera, and by the light falloff on her shoulder nearest the camera. Not posing her in this way would have created a large, eye-catching white area below the profile. See Diagram 12.

*T*he opportunities for creating beautiful window-light portraits are endless. In almost any situation where there is light from a window, you can capture images that will delight your subjects. This is especially true now that ISO 800 color film and digital capture at double that speed are available.

■ OBSERVING THE LIGHT

The major difference between making portraits by window light and making them in the camera room is that window light requires you to adjust your subject and camera to the light instead of the other way around. However, the basic principles are the same for both disciplines. When using window light, recognizing light patterns is even more important than when adjusting studio lighting.

Direction of the Light. When creating a window-light portrait, the first task is to recognize the direction of the light (or lack of direction of the light). When the sun is undiffused there is both a positive and negative side to the light source, and you have to decide which side of the light you want to use. On the positive side, the light will be brighter and more specular. On the negative side, it will be softer and less intense. See Diagram 13.

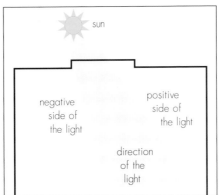

Diagram 13—The farther the sun is to the left in this diagram, the softer the light will be at the left of the diagram.

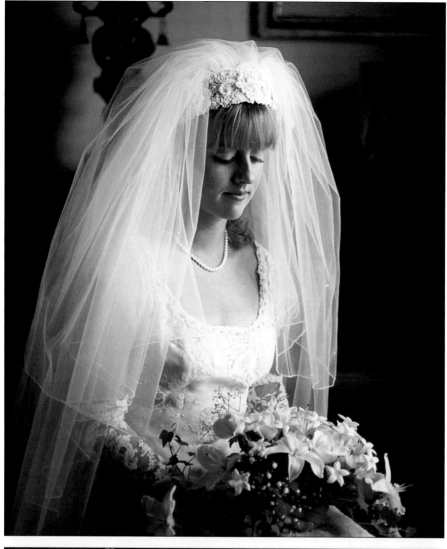

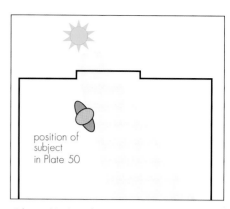

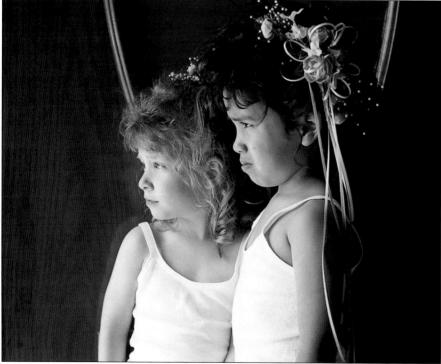

Plate 50 (top left)—Note how the pure window light models the face, as would a camera-room main light. This is due to the placement of the subject within the available light. See Diagram 14 (above). Plate 51 (bottom left)—This is really a wedding candid, but it illustrates that by recognizing the direction of natural light you can create an instant portrait without manipulation of the subjects.

Negative Side of the Light. Plate 50 shows a bride on the negative side of the light source. She was posed about six feet into the room so that the subdued ambience of the room could be seen behind her. This also allowed the natural light to work as the sole light source; no additional lighting tools were required. Had she been closer to the window, the light ratio would have been greater and required a fill light.

In Plate 51 you see two little girls looking out a window. The negative side of the light source was again used because, at the time of the exposure, the sun was not diffused. This naturally created a good lighting pattern for a low key profile portrait—without the need for additional lighting tools.

Positive Side of the Light. Plate 52 was exposed on the positive side of the light, using a more specular and masculine light. The subject

Plate 52—For this portrait the subject was placed on the positive side of the sun's direct light path, but slightly into the shadows as if the light had been feathered across the plane of his face. This produced a strong masculine look.

was placed slightly out of the direct path of the undiffused sunlight. This created a longer light ratio in the lighting pattern. The subject was also placed just to the right of the deep shadow from the wall in front of him. Using the heavy shadow from the wall increases the dramatic effect of the light and holds the portrait deeply in low key.

Plate 53 uses the same window light but in a different way. This time, the male subject is both closer to the window and turned slightly inward. This creates a stronger, more masculine image. Note that there is a longer ratio between the highlight and shadow sides. There is just a hint of the main light on his cheek, and there is less than 1/2 stop difference between the eye on the key light side and the one on the shadow side.

You could create the same lighting pattern in the camera room with a single soft box, as seen in Plate 27, which was discussed earlier and is repeated here for reference. There are distinct similarities between these two portraits. The primary difference is that the field of light from the window is significantly greater than that produced by the soft box. This means there is more light in the room, which assists in illuminating the background.

■ MULTIPLE WINDOWS

In Plate 54 (next page), the lighting was from two sides. The subjects

Plate 53 (left)—Placing the subject closer to the window increases the light ratio so that you have a very strong masculine portrait. Compare this with studio portrait seen in Plate 27 (right), repeated here for reference.

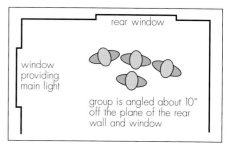

Plate 54—Placing the group in this lighting set requires you to recognize the light value of each source of window light. See Diagram 15 (above).

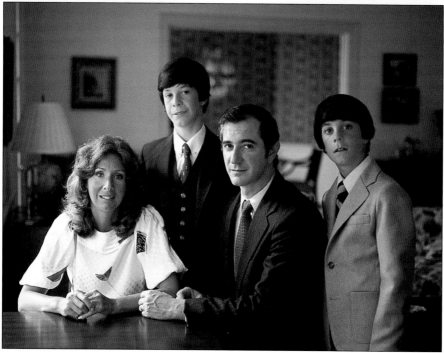

Plate 55—To create this portrait, I had to determine which of the two windows would produce the better lighting pattern. The other window then provided light to bring in the background.

similar light pattern on the figure at the right as it has with the other three subjects. This is another example of how, with window light, you must adjust the subjects to the light and not the light to the subjects as in the camera room. Please see Diagram 15.

In Plate 55, the light from the two windows was used in a completely different way than in Plate 54. In this portrait, the light from one window was used to illuminate the background and reveal the ambience of the home in which the portrait was made. The main light was from a window at the left. The subjects were positioned so that the light was feathered, skimming across their faces. This is a very pleasing form of lighting for this kind of portrait. It is

were placed to take advantage of the stronger light from the window at the left. The window behind the group acted as a back light, which provided illumination to the shoulders of the men in dark suits. In choosing to create this portrait with this lighting set, I first determined that the window at the back did not

provide an excess of light that would cause the group to be too brightly lit. The light from this window is almost equal to that of the window at the left.

Group Portraits. The group has been slightly angled off the plane of the wall behind them so as to allow the window at the back to produce a

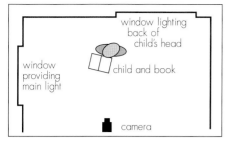

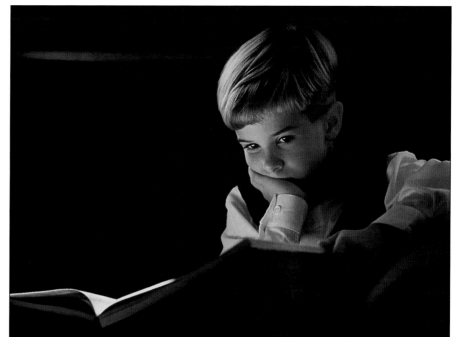

Plate 56—This is another portrait that uses more than one source of window light. Note the reflected light on the book, which in turn lights the boy's face. See Diagram 16 (above).

Plate 57—This portrait captures an intimate moment for the couple. To capture an image like this, you have to recognize the pattern of light that any particular window will provide.

gentle yet strong, which is important to the image of the women.

It should also be noted that the white-attired woman in the group was placed at the end of the group. Placing her in any other position would either have caused her to be lit unflatteringly, or would have drawn attention to her white blouse. Generally, it is not a good idea to place the person wearing the brightest or lightest clothing in the center of a group, as you will draw too much attention to them.

Children's Portraits. Plate 56 also shows a portrait created using the light from more than one window. Windows provided both the main light and the light that illuminated the back of the child's head. The main light was from the window

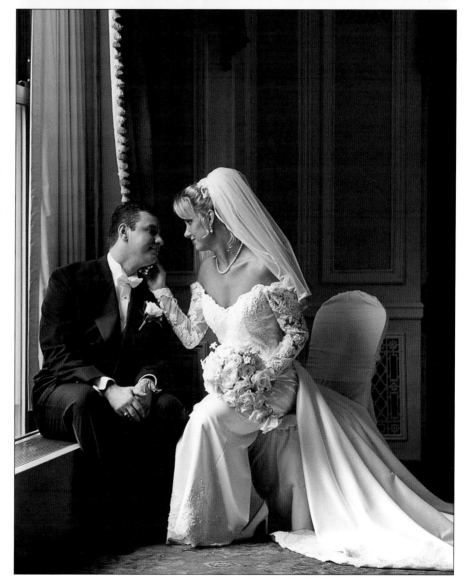

to the left, and the light reflected from the pages of the book acted as a fill light (like a reflector). See Diagram 16.

Compositionally, this image is a classic. The light lines of the book lead you to the child, yet the bright white of the pages do not distract from the story of the portrait.

Wedding Portraits. When making wedding portraits, the opportunity to use window light should never be missed. In Plate 57 (previous page), the interaction of the bride and groom produced a portrait showing a romantic and intimate moment. It is the perfect subject for window light. The groom was placed with his back to the window so that he faced the bride, who is illuminated in a beautiful profile as she caresses his cheek. The fact that his profile is not classically lit helps to portray

the fact that the groom is virtually in a swoon.

While the portrait is of a couple in a romantic situation, the main focus of the portrait is the beauty of the bride and her gown; the groom is the foil. This image was created on the positive side of the light, which you can tell by looking at the light on the bottom of her gown. Note that the couple has been tucked into the corner so as to avoid being burned out by the more direct sunlight.

■ **FLAT LIGHTING**
Flatly lit portraits are almost exclusively made in the camera room, even though the effect is more difficult to create here due to the relatively small sizes of studio light sources. Even the Westcott Octagbank Box, an excellent modifier, cannot quite equal the source that produces window light.

Flat window lighting can produce some delightful images, as demonstrated in Plates 58 and 59. In Plate 58, the subject was placed

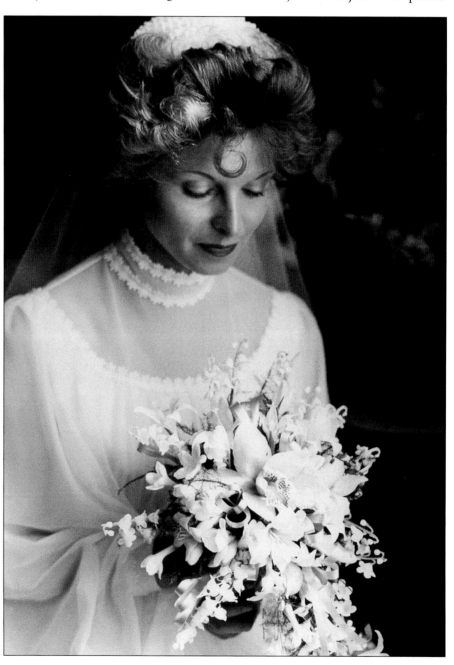

Plate 58 (above)—Overcast window light without any particular modeling can produce an enchanting portrait. Plate 59 (right)—To create this delicate portrait, the bride was placed much like the subject in Plate 58. The difference was that the sun was diffused instead of overcast, and the light was a little more directional.

about six feet from the window so that the overcast, non-directional light from the window would fall on her. This meant that the full-face view was lit by non-directional light that virtually eliminated facial modeling. The advantage of this lighting technique is that the eyes have mysterious quality that is not often reproduced by camera-room lighting. No matter where you are in the room where this portrait hangs, her eyes appear to follow you.

Plate 59, a delicate portrait of a petite bride was deliberately exposed with flat lighting so as to render both the delicate facial structure of the subject and the equally delicate gown. The key difference in this portrait compared with Plate 58 is that she is a little closer to the window but still out of direct light and slightly angled away from the window. This allowed the light to delightfully model her delicate features. In addition, the camera was used at a different angle to take advantage of the modeling that this form of light can produce. Obviously, the light in this portrait is a little brighter than in the other example and creates more precise modeling.

Underexposure. When creating flatly lit portraits, be careful not to underexpose them, or they will lack charm and vitality. Flat lighting generally requires you to be generous with your exposure by up to 1 stop, though if you are shooting digitally you may need to test the effect with several exposures.

■ WEDDING PORTRAITS

Some of the most obvious opportunities for low key window-light portraits are in wedding photography—

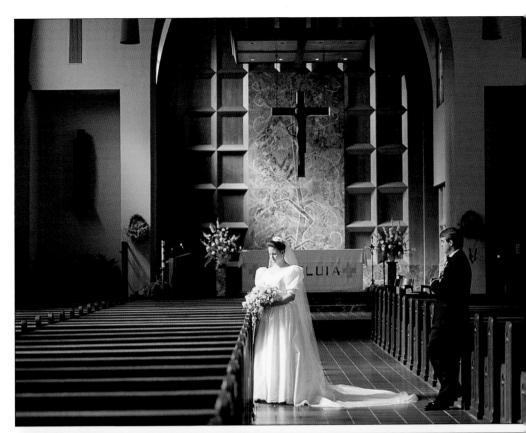

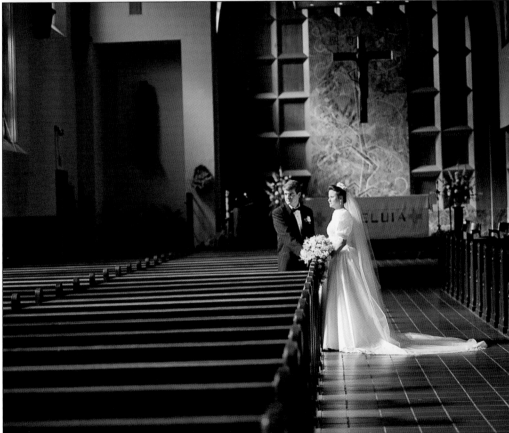

Plate 60 (top)—Note how the bride was placed at the best position in the aisle to pick up the light from the window. Plate 61 (bottom)—The bride's position was changed little from that in Plate 60. The groom was simply added to the composition.

though many are passed over because wedding photographers are pressed for time and have other logistical issues. With a little planning and observation, however, these portraits can be created in just a few minutes.

Plates 60 and 61 (previous page) were created by stealing a few minutes out of the busy day to place the bride and groom in the aisle, where the sunlight swept through the window. This situation was envisaged prior to the service; all that was needed to accomplish it was a few moments to get the couple where they were needed.

In Plate 60, the bride was placed in the direct path of the sunlight. She was slightly turned to show a three-quarter face. The light reflects from her gown to fill the shadow side of her face. The groom was placed as a supporting element—a technique with many applications outside of wedding photography.

In Plate 61, the groom was brought into the focus of the light

Plate 62—The window light for this portrait was from a very high position near the ceiling of the sanctuary. The placement of the subject had to be just right or there would not have been adequate light to pick up his eyes. It was also important that the scale of the sanctuary be captured in the portrait.

Plate 63—The angle from which this portrait was made allowed the window light to create rim lighting on the boy's face while the rest of the image falls deeply into low key.

and acted as a foil for the beauty of the bride and her gown. Here, the bride was turned for a profile view.

Plate 62 shows a rabbi in his synagogue sanctuary. The available light used could very easily have been overlooked, as it is all from above the minister. By positioning him carefully, however, both the rabbi and the sanctuary were beautifully illuminated and exposed. Bear in mind that natural light predominately comes from above, so this lighting is typical of many natural-light situations.

Little boys attending weddings are often bored and do not know what to do with themselves. A little observation and rapid portraiture as they explore their surroundings and entertain themselves can produce wonderful storytelling images. In Plate 63, the child is peering out the window and the light has created a very pleasing rim light. The rest of the portrait, other than the window, is deep in low key. Note that the portrait was created with the subject in the negative path of the light; this is why you see a rim of light, and the highlight-to-shadow side of the portrait is at a long ratio of 6:1. The negative side of the light provides opportunities to produce both rim-lit semi-

Plate 64—This is a caricature-style portrait. Their clothes do not fit, which adds great storytelling and is emphasized by the low key background.

Most maternity portraits are made in the camera room, but, when the opportunity arises, you should make them at the expectant mother's home. In Plate 65A, the crib was positioned in the shadowed corner of the room so that the window light illuminated only part of it. A little of the white curtain was allowed to form the left margin of the set. The subject was positioned in the negative side of the light for a very soft and subdued effect.

Window light can present opportunities to create something totally different, like the mirrored image in Plate 65B. With the light source coming from the extreme left of the camera and a dark background outside the window, the child's face is completely mirrored in the window. For this to be successful, the child's face must be very close to the glass. This provides you with a double portrait, which will make the parents very happy.

In Plate 65C, a completely different use of the window light was employed. The portrait was made with the light reflected off the wall behind the camera and one reflector, producing a very soft and subtle portrait. The window light was then used as a kicker. This is a technique that few would consider, but one that can provide a completely different impression from conventional lighting plans.

or full-profile silhouettes. These can be varied for numerous styles of portraits; all you have to do is use your imagination.

In Plate 64, two little boys attending a Jewish wedding create a caricature image. The low key setting enhances the impression because it presents their amused faces in contrast with the background. This style of portrait uses light primarily from above. Choosing not to use fill light enhances the caricature nature of the image.

■ IMAGES IN A SERIES
One of the following three images (facing page) is part of the story of an expectant family. Because each portrait has an inherent message, however, the images could be grouped or used individually.

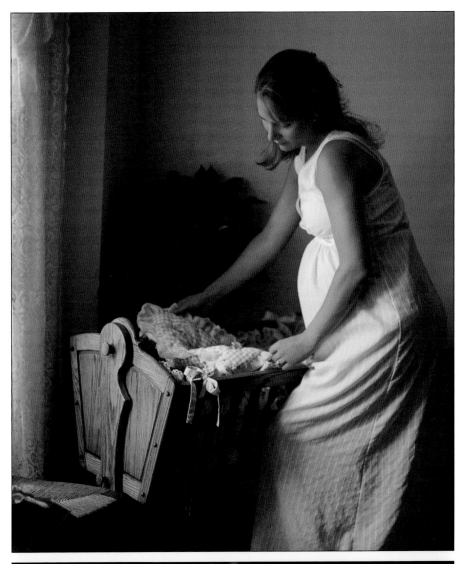

Plate 65A (top left)—Expectant mothers imagine the realization of the baby's arrival. Capturing this dream in a portrait requires subdued lighting. Plate 65B (bottom left)—Creating this portrait without having clutter in the background behind the mirrored image requires you to find the right type of window-light situation. Plate 65C (below)—This portrait pairs the natural light as a kicker with ambient light bounced off a wall and a reflector.

10.
Studio Portraits of Children

*T*he biggest segment of the portrait market is children. Children offer the widest field for creativity, since a variety of lighting setups, backdrops, props, and poses can be used. Additionally, it is much easier to create storybook-style portraits of children than of any other subject.

■ LIGHTING

Balance with Backdrop. In Plate 66, the photographer captured this bright-eyed youngster against a painted backdrop with an impression of the outdoors. This kind of backdrop is very popular with professional photographers, and the out-of-focus outdoor impression helps create perspective in the portrait. While the portrait is one that any parent would be delighted with, notice that the balance between the lighting on the child and the implied lighting of the backdrop could be better. Still, the lighting in this portrait is obviously the work of a master; the boy has an almost three-dimensional appearance.

Flat Lighting. Plate 67 uses a similar technique to the one seen in Plate 66, except that the child was turned slightly away from the camera and the backdrop appears rendered even more impressionistically than the one in Plate 66. The diffusion painted into the backdrop makes it less obvious that it is a backdrop and not a real outdoor scene. Note the lighting difference between these two portraits. Plate 67 has flat lighting, and the child's face appears rounder because of it. Using fill lighting with a full- or three-quarter-view portrait makes the face appear rounder and wider, as it does not create strongly recognizable lighting patterns.

Flat lighting is achieved in several different ways. First, you can move your subject away from the light source and use it with any specific direction as discussed in the previous chapter. Second, you can use a broad field of light

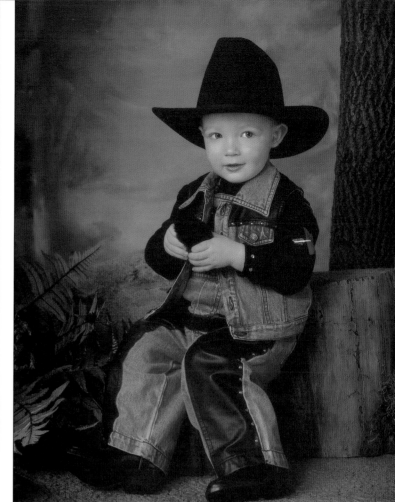

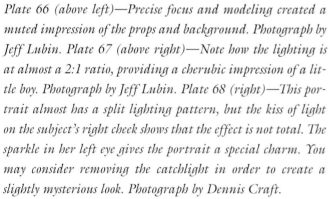

Plate 66 (above left)—Precise focus and modeling created a muted impression of the props and background. Photograph by Jeff Lubin. Plate 67 (above right)—Note how the lighting is at almost a 2:1 ratio, providing a cherubic impression of a little boy. Photograph by Jeff Lubin. Plate 68 (right)—This portrait almost has a split lighting pattern, but the kiss of light on the subject's right cheek shows that the effect is not total. The sparkle in her left eye gives the portrait a special charm. You may consider removing the catchlight in order to create a slightly mysterious look. Photograph by Dennis Craft.

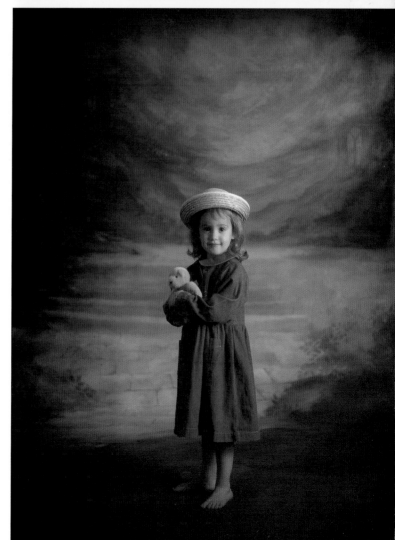

from a single source as wide as 72", or from a bank of more than one light placed together and directed straight onto the subject. If you build a wall-to-wall light source and place it at the back of the camera room, the light will have less ability to render radiant skin tones and will require you to liberally expose the subject in order to obtain acceptable skin tones.

In Plate 67 (previous page), the photographer used a soft light as the main light and placed it slightly off the camera axis so that there is a gentle ratio of 2:1. The result is light that is almost frontal and flatter than any previously shown lighting pattern. This is a very acceptable ratio for a small child and creates a cherubic appearance.

Split Lighting—Almost. In Plate 68 (previous page), the photographer has used a most unusual lighting pattern for a child's portrait. While he has almost split his lighting, you can see a little light on the child's right cheek so the effect is not total. While you can see her shadow-side eye, there is no catchlight in it. You may consider taking out the catchlight in the other eye in order to create a slightly mysterious look.

Split lighting is most commonly seen in masculine subjects where you want to show strength and generally portray your subject in a relatively serious mood. In this portrait, however, the girl's warm, soft expression works as a counterpoint to the lighting pattern. It is this glimpse of the child's personality showing through that allows the photographer to get away with this unusual lighting set. Should you attempt a portrait of a child with this lighting style, be sure

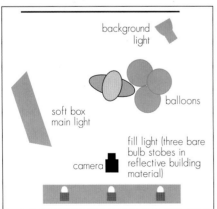

Plate 69—This is a very pretty picture that captures the essence of a little girl with balloons. The color and harmony of the clothes, balloons, and background are exceptionally well done. Photograph by Kim and Peggy Warmolts. See Diagram 17 (left).

to capture the appropriate mood; otherwise, the parents may not appreciate your work.

■ VIGNETTING

Plate 69 (facing page) is an excellent example of both low key children's portraiture and presentation. The backdrop has a perfect center of brightness for this image, and the well-considered position of the child in relation to the vignette painted on the backdrop ensures that it does not clash with her dress.

The main light was placed at a 45° angle to both the camera and subject, and the fill light was placed behind the camera, creating a very pleasant 3:1 ratio. There was also a background light directed at the center of the backdrop. This increased the brightness of the light-colored center of the backdrop. See Diagram 17 for the lighting plan.

Using balloons as a prop can create problems in composition, but here it is handled well. The color of the balloons is clever; they are slightly darker than the child's dress, so they are not the first thing you see in the portrait. The vignette at the bottom right helps to create a leading line to the focal point of the portrait.

■ BLACK & WHITE PORTRAITS

The renaissance of black & white photography that began in the middle to late 1990s made better photographers more successful, because rendering these images to a high professional standard required an excellent understanding of continuous tone. In Plate 70, the photographer produced an image that has both deep and clean tones. This was achieved by ensuring an adequate

exposure. The lighting pattern rendered the child's nose almost perfectly—not as easy in a full-length portrait as in a close-up. The main light in this portrait is that directed onto the girl's face, not that which lights the rest of the figure. The backdrop

has a natural vignette, so there was no need to specially light it.

■ YOUNG CHILDREN

Photographing children under three years of age presents a special challenge—their feet and hands some-

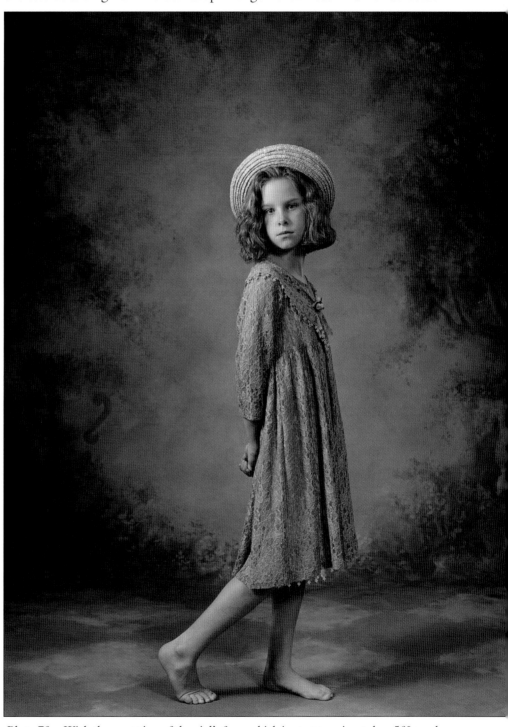

Plate 70—With the exception of the girl's face, which is at approximately a 50° angle from the key light, the entire tonality of this portrait is low key. The lower angle of the camera gives her a slight look of aloofness. Photograph by Robert (Bob) Summitt.

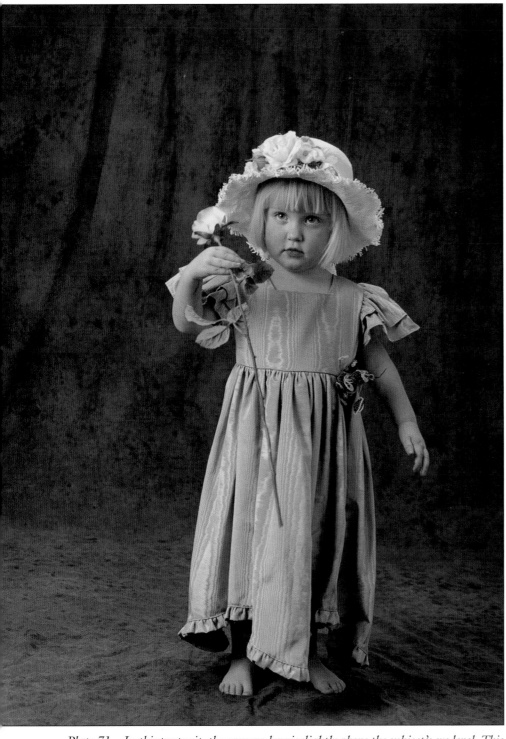

browns, reds, pinks, and black. Across the background, a focusing mono-spot with a cerise-colored gel lit the folds in the muslin to add an accent of color behind the child's head. The main light was a 40" soft box with a gray interior and two scrims. The hair light was a diffused 48" strip box. The fill light was a Westcott Halo Mono, bounced off the side wall to the child's left (camera right).

The double scrim on the main light, which was placed at a 45° angle to both the subject and the camera, produced a gentle modeling with a small loop shadow from the subject's nose. The fill light, bounced off the side wall, lit her left arm in a way that a fill light from behind the camera could not. As a result, the entire figure has a balanced lighting pattern.

The use of a soft box with a gray interior produced a softer light with more control than a soft box with a white or silver interior would have. This form of light was ideal for the subject. Had any other soft box configuration been used, the child's hand that held the flower would have been too bright. It would have required burning in during printing.

■ GROUPS

Plate 72 shows a group of dancers creating a *Cabaret*-style portrait. The black background and the subdued expressions on the girls' faces match the somber tone the title implies. The black costumes and the dark background caused their skin tones to be seen in bright relief, so the lighting needed to be even across the plane of the group. Therefore, a 48"x28" Westcott Apollo was used with two scrims. The box was turned

Plate 71—In this portrait, the camera lens is slightly above the subject's eye level. This caused her to look upward, which increases the impression of innocence. Note the soft loop lighting pattern to her nose. The stem of the rose she is holding emphasizes her size.

times seem hopelessly out of sync with their delightful little heads, and they often will not remain in the lighting pattern that you set up for low key portraits. When you get it,

though, the methods and patience needed to capture this kind of innocence are immediately worth it.

Plate 71 was made with a nondescript patterned muslin backdrop of

Plate 72—Black hats, black costumes, and a black background were used to create the impression of Cabaret, a somber musical review. The lighting and background had to match the mood of the concept. Creating separation here requires a soft light source.

horizontally to create a wider field of light, which was slightly feathered so as to ensure that the light would be as even as possible across the plane of the group. A 48" soft box was used as the hair light, and a Westcott Halo Mono was bounced off the side wall as a fill.

Shooting black-on-black while creating separation required that I used enough light to illuminate the hats but not so much that it would blow out the skin tones. Adding the second scrim on the main light allows for additional exposure with-

out excessive contrast, which would have been the case if only one scrim had been used. The harder the light source, the more contrast, and when hard light is used on a subject with black attire, it is impossible to create detail in the blacks.

■ TEENAGERS

Teenagers are much easier to photograph than toddlers, as they are able to stay within the lighting pattern. They also can be drawn into the frame of mind you want for your portrait. Many people think that the

conventional smile is what is needed for a beautiful image. A pensive look is often more beautiful, though. Plates 73 and 74 (next page) illustrate the different impressions that can be created by changing the perspective of the camera and cropping in the camera.

In Plate 73, the impression is rather innocent and could be described as a "daddy's girl" style. The slightly questioning look in the girl's eyes and the turn of her head slightly up toward the camera created this impression. In contrast, Plate

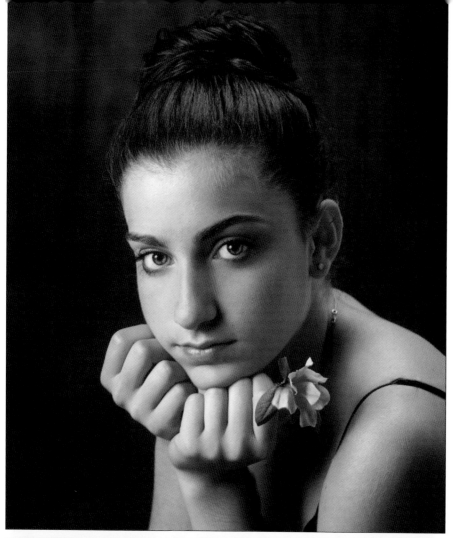

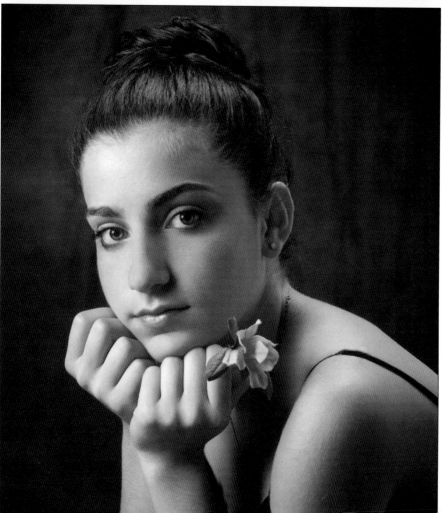

Plate 73 (left)—Low key was chosen for this portrait because the color of the skin tones stood out against the neutral background. Note how the lens perspective, higher in this portrait and lower in Plate 74, causes her to have two different representations. Plate 73 has a "daddy's girl" feel, while Plate 74 has a more sophisticated character. Plate 74 (right)—The lower camera angle makes the subject seem to be looking slightly down at you. The innocent look seen in Plate 73 has turned to slight sophistication.

74 shows the girl photographed from a lower angle in almost a half-figure portrait. A little change of the look in the eyes created a more sophisticated impression. It makes this thirteen year old look a little older and more grown up.

In both of these portraits, the main light was a soft box with a gray interior and two scrims. The fill light was bounced off the sidewall, and a strip soft box was used as the hair light. The main light was placed at about 55° off camera axis, approximately 40° off the subject axis. This allowed for the creation of a lighting pattern that falls in between the loop and butterfly styles. It also provided even lighting on the frontal mask of the face—the nose, cheekbones, forehead, and chin.

In this portrait, the use of the hands created a challenge because it was important that they not be over-illuminated. Otherwise, they would have been the first and last thing that you saw in the portrait. Here, they are almost exactly the same tone as the face. You should always remember that hands have lighter skin tones than faces and require you control

your lighting to avoid producing eye-catching elements that compete for attention.

■ HARMONY OF LIGHTING AND SETTING

Plate 75 is a completely different style of portrait that could have been made either on a set built in the camera room or on location. Window light played a part in the lighting set, but the primary light came from overhead and was reflected from the computer that the child was using. A careful examination of the shadows is what reveals the direction of the lighting—look especially at the light on the boy's head, as well as how the shadows cast by him, the computer, and the table follow the logical direction of an overhead light. There is, however, enough illumination on the back of the computer to suggest that window light played its part in the

Plate 75—This portrait is so well done it almost makes you believe the story it tells. This kind of storytelling portrait must be made with special care, so the only lighting used was the available light in the scene. A wrong lighting pattern would have made this look artificial. Photograph by Dennis Craft.

lighting set. It is a delightful piece of fantasy. This expertly created portrait is a reminder for us to always ensure shadows properly relate to the intended lighting pattern. If we do not, then the images will not have a realistic look.

Plate 76 is a studio portrait made with the aid of a modular background set. The dress the subject wore was chosen to closely match the wall and ledge she was sitting on.

In this type of portrait, the main light must be feathered across the set at a fairly sharp angle. Otherwise, the highlight side of the wall would have been much too bright and the portrait would have seemed off balance.

The sharp feathering of the main light is largely successful; the difference in brightness of the left and right sides of the wall is less than ½ stop. This is easily corrected in printing, but even without this correction it is not overly noticeable.

The background used behind the child is a nondescript pattern of black and deep grays. From the camera's position, however, it would have been solid black. Therefore, a focusing mono-spot was used to create an impression of movement behind the girl. The fill light for this portrait was a Halo-Mono from behind the camera.

Plate 76 (facing page)—The child's dress and the wall tones were matched so as to present a harmonious image against the deep toned background. The key light was feathered to illuminate the wall evenly. The right side is ½ stop brighter than the left and is barely noticeable.

CHANGING THE FORMAT

Photographic papers come in standard sizes, which often are not the best shape for the best presentation of your portraits. Instead of the standard 4"x5" or 5"x5" formats, consider modifying the shape of your portraits so that they have the best composition. Additionally, this demonstrates your creativity and elevates your image within your market. This is a method used by photographers entering print competition and mostly results in greater success. Using this method of presentation also creates opportunities to sell custom-matted and framed portraits, which are more profitable.

11.

Composition

The composition of your portraits is as important as the lighting, posing, background, and props. When the design of the composition is not carefully considered, the elements of your portraits will become individually obvious rather than be seen as a comprehensive whole. If you have ever entered or attended a print competition, you probably noticed that the judges tend to critique prints more on the basis of lighting and composition than any other quality.

■ RULE OF THIRDS AND THE POWER POINTS

This is a design guide for the composition of photographic images, though you could use the same principles in other works of art and design. Diagram 18 illustrates how these rules are applied.

In the diagram, the 4"x5" format is set in landscape mode (horizontal). In the rule of thirds, the frame is divided into thirds both horizontally and vertically. Whichever way you turn the frame, the lines dividing the thirds do not change. In either orientation, the four points at which the dividing lines

Diagram 18—The power points, here indicated by the red dots, are at the intersections of the grid lines.

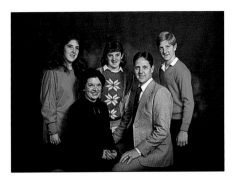

Plate 77 (above)—This image illustrates the difficulty that mixed colors in clothing can create. Plate 78 (right)—Having the bride seated and the children on the floor allows the low key background to show them in relief. It also emphasizes the little girls' smallness.

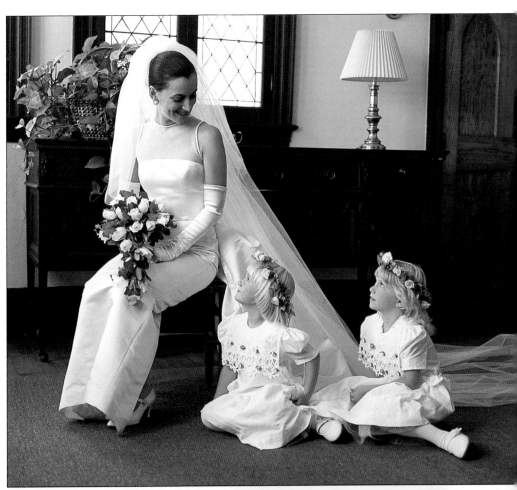

intersect are called the power points. These are the spots where you will generally seek to place the focal point of your composition, and using them correctly will help to draw your viewers' eyes to the most important element within your composition.

Using the rule of thirds and the power points is not always feasible—especially in tight compositions and groups that require that the entire frame be filled. Still, the rule of thirds is a very important guideline toward the best composition.

■ COLOR AND COMPOSITION

In Plate 77, the family group chose to wear an assortment of colors and patterns that created compositional problems. To overcome this problem (to some degree), the green-clad subjects were placed at the ends of the grouping and a transitional arrangement was created for the other three figures. This largely offset the ill-considered clothing choices of the family. The placement of the hands also helped to create a circular line around the group to enhance the sense of harmony.

Note the two diagonal lines in the composition that run through the faces of the subjects from both sides of the group. They help to offset the eye-catching pattern on the sweater of the girl in the center.

■ SIZE AND COMPOSITION

In Plate 78, the three figures were placed so as to emphasize the difference in the sizes of the subjects, and to allow the low key background to present the white-clad figures in relief. This composition yields more dynamic impact than having the two little girls standing beside the bride.

■ CAMERA ANGLE

Plate 79 shows two sisters reading a book. The angle from which it was taken presents a more dynamic image than if it had been photographed

Plate 79—The concept of this portrait is that these girls are reading a Jewish prayer book on the Sabbath, hence the traditional candle. The angle of view has the book off center so that you have a very slight side view—much more interesting than a straight-on camera view.

from the front with the book centered. It also brought the candles into a more dynamic position at the left of the image. Had they been anywhere else, they would have been a distraction rather than an accent.

■ CROPPING TO IMPROVE COMPOSITION

Compare the composition of Plate 80 with that in Plate 81. In Plate 80, allowing the white trim of the subject's clothing to show compromised the dramatic lighting; it clashes with the beautiful face and headpiece. In Plate 81, the in-camera cropping created a much more dynamic and alluring impression.

■ USE OF SPACE

In most head-and-shoulders portraits, the photographer will choose to create the image vertically. However, this often cramps the composition, squeezing the head into a relatively uninteresting place in the frame. In Plate 82 (facing page), the head-and-shoulders portrait was composed as a horizontal instead. Note that the subject's head was turned slightly to look across the format. As a result, the additional space around her allows the image to have a dynamic that it would lack if composed as a vertical.

The skillful use of space in your composition will make your portraits more appealing and creative. You will want to resist the requests of your clients to reduce the space or eliminate areas and elements in your composition. Clients are usually not well educated in the creative arts, and it is our role to instruct them in the appreciation of our work not just as portraits but as works of art.

In Plate 83 (facing page), the photographer placed the child at a power point in the composition. This effective use of the space emphasizes the child's size in relationship to the room in which she is portrayed. To reduce the space around her would have reduced the artistic appeal of the composition; it would no longer be a piece of art.

Plate 84 is a delightful composition, which again shows the child in

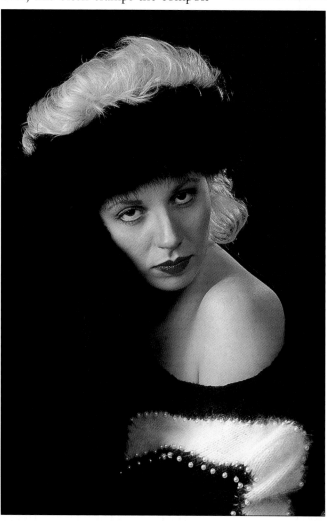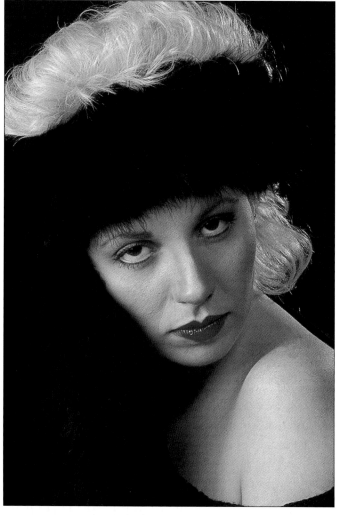

Plate 80 (left)—Including the white trim on the woman's dress creates a distraction. Compare this to Plate 81. Plate 81 (right)—Eliminating the white trim and moving closer yielded a much more dynamic image in which the woman's eyes are looking more directly at you.

Plate 82—This placement of the subject in the format has a much more artistic design than if the portrait were vertical. A portrait image can often have greater appeal when given space to "breathe."

scale with her surroundings. The fact that the little girl is not centered makes the dynamics of the portrait more appealing. The clever use of the mirror adds a second image of the child without detracting from the main focus of the portrait. The placement of the flowers additionally supports the delicacy of the image.

■ ON-LOCATION

Framing. In the camera room, you can create a set and arrange your lighting to fit almost any design. On location, however, the set is already there and you have to design your portrait based on what is available. In Plate 85, the light coming from the left created a frame against the darker areas in the hallway. The boy is

Plate 83 (left)—Note how the placement of the child in this portrait has her face almost exactly in the power point position, which is emphasized by the low key background. It is an example of the use of simple dynamics. Photograph by Dennis Craft. Plate 84 (right)—This is another example of the power-point placement of the focal point of the portrait. Additionally, though there is a fairly bright element at the left, the brightest element is the child. Photograph by Dennis Craft.

Plate 85 (left)—This is another example of placing the focal point of the portrait using the rule of thirds. Here the boy was placed in a frame created by natural light and at the lower-right power point. Plate 86 (top right)—In this composition, the boy's head is between the two left-side power points. Photograph by Dennis Craft. Plate 87 (bottom right)—This is wonderful portrait of a child on a beach. The composition is perfect. It uses space to create a feeling of the vastness of the water and a leading line to draw your eye to the subject. The lighting is also perfect and the diffusion adds a little magic. Photograph by Dennis Craft.

positioned in the bottom-right corner of this frame so that there is a relativity of scale between him and his previous portraits, which adorn the walls of the hall. The light from the left creates a striking profile of the child. Note, too, that by including just the right amount of the darker floor below, the boy is placed at a power point in the composition.

Environmental Portraits. Environmental portraiture offers the opportunity to create images that are unusual and employ creative composition. In Plate 86, the photographer used space to create a portrait that tells much more of a story than if he had tightly cropped the child into what would have been a more conventional presentation. This composition shows the child in a total environment rather than squeezed into a tiny element of the scene. If you are seeking to profit from your portrai-

ture, then this kind of picture has potential to sell a print significantly bigger than an 8½"x 11"; it has the potential for at least a 30"x40" portrait. However, bear in mind that when creating a portrait to be made 24"x30" or larger, you will want the head size to be no more than 5%–10% greater than life size. For a child, this requires you to ensure the size of the subject in the composition will not create a head size in the enlarge-

ment that is greater than 8" from the bottom of the chin to just above the forehead. In an adult portrait, this should not exceed 10".

Leading Lines. Should you wish to create a portrait that is a true work of art, then Plate 87 (facing page) is a great example of an image worthy of at least a 30"x 40"—perfect to grace the wall of any client's home. The child is perfectly placed at the power point in the composition. The surf created a leading line from the left that takes you directly to the little subject. The child is placed in the path of the light and in beautiful profile. Because the portrait was made late in the day, the blue water has made a wonderful low key backdrop.

■ BLACK & WHITE

When creating low key portraits in black & white you need to be mindful as to how all of the colors in the clothes and scene will translate into gray tones. Should you not consider these factors, you may well find that you will have merging tones that do not separate the subjects and the background.

In Plate 88, the photographer was presented with elements that could have created distractions in his composition. The boy in dark clothing was placed so that his darker clothing separates from the lighter area behind the boys, while the boy in white was placed against a darker area of the background.

Additionally, note that the bright verticals of the home have been used to support the composition and do not dominate the overall tonal composition, which strong white lines in a low key portrait can do. The standing figure has been positioned so as

Plate 88—Designing a composition that includes strong white verticals and horizontals requires thought as to where to place your subjects. Here, the photographer broke the vertical plane of one white line with the boy in dark clothes and used another as a lead to the boy in white. This significantly reduced the impact of the bright vertical elements. Photograph by Dennis Craft.

to reduce the impact of the column. Had this column separated from the boy it would have created a distracting element.

■ CREATIVITY

The success of your portraiture depends on your ability to be innovative and to create unique images, and low key seems to offer endless scope to get your imagination going.

Communicating Emotion. Plates 89, 90, and 91a demonstrate how you can create portraits that challenge the viewer and convey both mood and attitude. Each also uses low key to show the psychology behind the portrait.

In Plate 89 (next page), the skin tones of the subject are isolated, virtually buried in the black of the background and the youth's hair. Placing

Plates 89 (above), 90 (top right), and 91a (bottom right)—Each of these three portraits uses space to create a feeling of isolation that in turn creates mood and attitude. Photographs by Robert (Bob) Summitt.

the subject in the bottom corner suggests the subject is reclusive. It exudes an attitude.

Plate 90 uses space in a similar way, but because it is in a horizontal format, the impression of the subject is different. It presents an image that suggests the subject is in a state of concentrated thought.

In Plate 91a the young man was placed at the bottom of the composition, creating the impression that time and the world are weighing down on him. Placing his hands on top of his head in this way suggests a feeling of being overwhelmed or in despair.

Taking Chances. Each of the portraits shown in this chapter demonstrates how you can create superior portraits with careful composition. This probably means you will take a little longer in designing the portrait either mentally or on paper. Don't rush into the project,

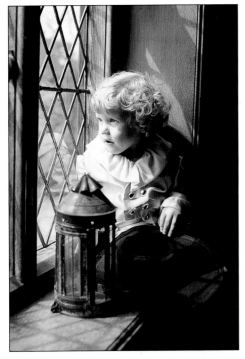

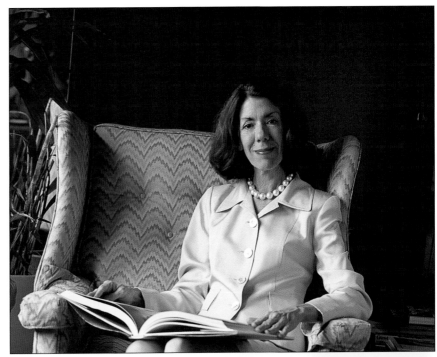

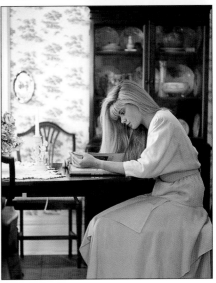

Plate 91b (top left)—This portrait was made in a historic English house. The lamp is an important element in the composition, which uses as much of the window set as possible without losing the sense of curiosity conveyed by the young boy. Plate 91c (top right)—This is another example of allowing the subject to "breathe" within the composition. The grand chair leads you to the focal point of the portrait without demanding undue attention. It also makes the portrait worthy of presentation as a large wall portrait. Plate 91d (right)—Note how the young woman, dressed in light clothing, was placed against the dark area in the composition so as to show her in relief. The overall effect is an engaging composition.

take your time and don't be afraid to take chances.

In Plate 91b, a small boy in period costume was photographed in a historic building. The lamp that calls to mind the 11th century is an important prop and helps support the story in the portrait. It is deliberately placed slightly in front of him (beside the hat) rather than farther away where it would have been separated from the subject and seen as a distinct compositional element. All of the elements that help tell the story are composed as a unit, so no single element becomes a distraction. Note also that the boy is on the positive side of the light.

In Plate 91c, the woman is placed at the far end of a very grand and obviously comfortable chair. In window light portraits there is often a tendency to place the subject close to the light in order to take advantage of all the light available and permit as fast a shutter speed as possible. In this portrait, however, the composition helps tell the story of the subject—how comfortable she is in her home and in this particular chair. The chair forms a frame for the portrait, and moving the camera a little to the right made the book she was holding form a leading line to the point of focus. This makes the portrait much more interesting and cre-

ates dynamics that would otherwise be missing.

In a subject's home, there are likely to be all kinds of elements that can compromise your low key concept. This is illustrated in Plate 91d. In order to create the portrait in low key, the young woman was placed against the darkest area in the room. Even though there is a relatively bright area in the image, the portrait is in low key.

12.
Using Diffusion

a technique that can enhance your portraits is the use of diffusion. Diffusion can be done either in-camera or during the printing process, and each technique will yield different results.

■ IN-CAMERA DIFFUSION

Most leading filter manufacturers produce diffusion filters. They are best used with filter holders that extend from the front of the camera, because with this configuration you are able to control how you wish the filter to work for you. Diffusion filters are a little different than soft focus filters, which are simply designed to reduce the sharpness and are a valuable tool when you are photographing people who want to disguise the signs of aging.

Diffusion works by converting the bright elements within the composition into transitional elements, taking away the sharpness and causing the image to look softer and a little bit romantic. Depending on the lighting, the diffusion may also create a slight halation, especially with light and bright subject matter. You can see this effect in Plate 88 (page 75). The halation can add to the charm and romance of an image, but when used without careful thought it can also be distracting or unpleasant.

■ DIFFUSION IN PRINTING

Diffusion in printing does not produce the same effect as when done in the camera. While it will soften the overall impression, it will not blend in the same way as demonstrated in Plate 92. The diffusion used in Plate 92 not only softened the image, it also blended the skin tones and reduced the

Plate 92 (facing page)—Note how a hint of diffusion creates an even softer portrait than just the softness of the widow light. Photograph by Dennis Craft.

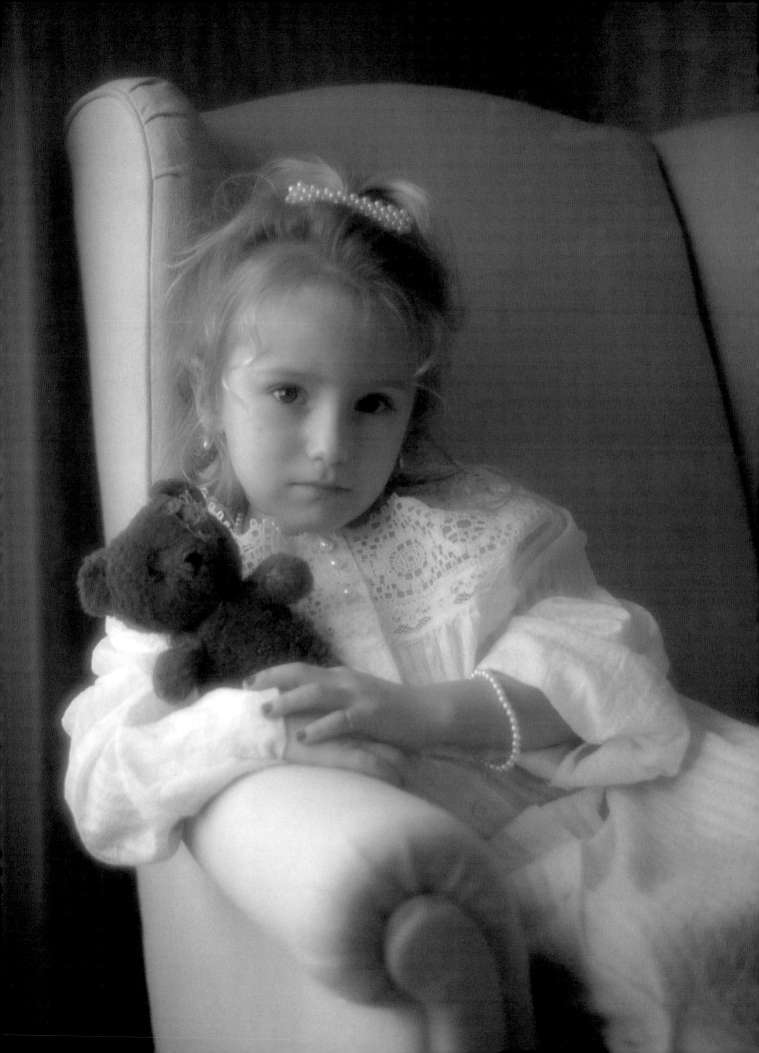

sharpness of some of the separating lines that the lighting pattern created. Though soft, it is not un-sharp. Compare this style of portrait to that in Plate 93, also taken with window light.

■ WHEN TO USE DIFFUSION

When comparing Plates 92 and 93, you should consider the subjects being photographed. The child with the teddy bear is very different from the child in Plate 93. One is clearly a slightly shy and quiet little person, whereas the blue-eyed girl with the bow in her hair is much more outgoing. Diffusion in the one portrait is appropriate, but it would not be the best choice for the other.

As you can see, diffusion is not for every portrait you will make. While diffusion can create a romantic impression for many portraits and blend the tonal values as discussed above, you can very easily overuse the technique. It is also, obviously, not the best choice for a portrait of a tough-looking biker, a football player in his team uniform, or a businessman who seeks to project strength and resolve.

While diffusion may best be used in portraits of women and children, there are many instances here too where this would not be a good

Plate 93 (top)—This is a deliberately tighter composition without diffusion. The child is a little chubby and cuddly— you could just hug her. Diffusion would take away a little of that huggable feeling. Plate 94 (bottom)—In this portrait, the diffusion blended the skin tones so that there is a smooth transition from one subject to the next. Photograph by Dennis Craft.

Plate 95—The combination of diffusion and a shallow depth of field make this portrait almost mystical. Photograph by Dennis Craft.

choice. The old concept that women should be portrayed as "soft and gentle" and "infinitely feminine" does not hold so well in modern society. Women have a strength that needs to be shown in your portraits. For example, a female military officer in uniform would not appreciate diffusion in her portrait. Choose your time to use diffusion with care and your portraits will always represent the subjects as they should.

■ SCENIC PORTRAITS

Don't forget about diffusion for your scenic portraits. In Plate 87 (page 74), the little girl is beautifully rendered in an image set against deep blue water, and the halation enhances the charm. In Plate 86 (page 74), however, diffusion would have been inappropriate. Little boys climbing rocks are not appropriate subjects for diffusion. To completely turn the coin the other way, see Plate 88 (page 75). In this portrait, the photographer used diffusion to create a little fantasy and at the same time take the sharpness out of the background.

■ LIGHT RATIO

In Plate 94 diffusion is again appropriate, as the light from the left created a longer ratio than the photographer wanted. The diffusion served to blend the tones so that they are more continuous. This type of portrait is an ideal subject for diffusion, since the softening and blending effect suits the subject matter. You can also see a very slight halation all the way down the boy's right side.

■ CLOSE-UPS

In the close-up portrait in Plate 95, the effect of the diffusion is more obvious, yet it does not prevent the eyes from being in focus—a major difference from the effect you'd achieve with a soft focus filter. This image was created at a wide aperture, throwing the child's ears and the hair behind them out of focus. The blending created by the diffusion filter simply creates a smooth and gentle transition from the eyes (the sharpest point) to the ears.

CLOSE-UP PORTRAITS

In close-up portraits, try to place the eyes of the subject at a slight angle. If the eyes are placed in a horizontal line, the subject will look disinterested or bored. This will be much more obvious in low key than other keys. You can create portraits with different expressions by changing the angle of your subject's head and having the subject look upward or downward.

13.
Hands, Arms, and Legs

*H*umans use their hands to augment the expression of their emotions. During excited verbal communication, we often do not notice instances where they might be positioned in ways that are less than flattering. When hand expressions are frozen in a photograph, however, they take on a different perspective.

Posing for low key may be more critical than in the other two keys; when a limb or hand is not well placed, it will virtually scream out. In many cases, poorly posed hands and arms spoil the portrait because they look inelegant or awkward. Therefore, it is important to place hands and arms in such a way that they complement the composition and the pose and do not distract from the focus of the portrait (usually the face and eyes of the subject). In this chapter we explore the do's and don'ts of posing hands and arms—and how they may complement the portrait or be detrimental to the composition.

■ CONCEALING OR REVEALING THE HANDS

Plates 96 and 97 show the subject with and without hands showing in the portrait. In Plate 96, there is a relatively large, empty black area below the young woman's head. In the second portrait (Plate 97), her hands are used as a base for the portrait and the black space is reduced. This pose brings the portrait into better balance.

■ POSING THE HANDS

Hands should appear comfortable and natural. Yet, when you ask a person to sit comfortably and simply place their hands in a natural position the pose they will adopt is usually not flattering. As a general rule, you should not show the palm or the back of the hands to the camera. Even the most beau-

 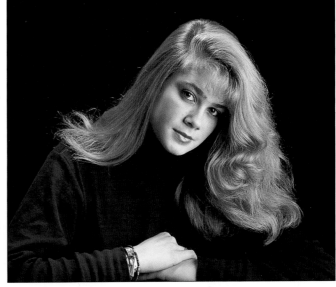

Plate 96 (left)—Note the empty black space below the girl in this portrait. Compare this with Plate 97. Plate 97 (right)—In this portrait, the hands create a balance in how the black space is used, and they better support the image.

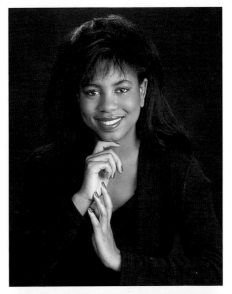 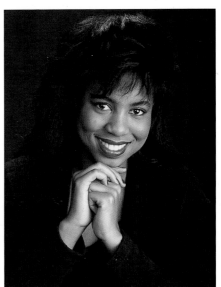

Plate 98 (top left)—Here, the overly elaborate hand pose detracts from the young woman's beautiful smile. Plate 99 (top right)—Note how the hands have been "dressed" so as to flatter them. This makes them an integral part of the portrait. Plate 100 (bottom left)—No matter how beautiful hands may be, it is very easy to make them look ugly. In this instance, they look like claws. Plate 101 (bottom right)—This spontaneous hand pose is acceptable because it is a natural movement of the hands. It should not, however, be used when you have direct control of posing.

tiful hands will not look their best when displayed in this manner. In order to make the hands seem slim and flowing, you should seek to show the hands from the side.

In Plate 98 (previous page) the model's hands are shown with their sides toward the camera. Even so, the posing is elaborate and you notice her hands before you see her beautiful smile.

The best method of ensuring that the hands look good is to have the subject place their hands in what feels like a natural pose and then "dress" or refine them. In other words, you should finesse the hands so that they look natural but also attractive. This technique was used to create the portrait seen in Plate 99 (previous page).

In Plate 100 (previous page), the subject's hands are less dominating, but they are still not very flattering—they almost appear claw-like. As you can see, even when showing hands from the side, they can still be badly posed.

In Plate 101 (previous page), the same model is showing pleasure at something and uses her hands to emphasize her feelings. Only the sides of the hands are visible and, because they are incorporated into the feeling of the portrait, they work quite well. This is not, however, a normal pose for hands in a portrait.

■ DISTRACTING HANDS

Plate 102 shows a beautiful subject with a wonderful smile, but the use of the hands is not good. It is a distraction in terms of both the cropping and the posing of the finger, which intrudes into the focus of the portrait. Had the model been wear-

Plate 102 (top)—Allowing the hand to intrude into the portrait is something to be avoided. It is a serious distraction and breaks down the composition. Plate 103 (bottom)—This is a rare example in which allowing the back of a hand to be exposed to the camera is acceptable.

PLACING YOUR SUBJECT

Plan your composition so that the focal point of your composition is at or near the power point on the rule-of-thirds grid. By doing so you will create much greater impact in your portraits. When other elements are included within your portrait, use them to support the focal point, possibly as leading lines to the focal point of the portrait.

ing clothing that was closer in tone and color to her skin tones, this position of the hand would have been more acceptable.

■ BACK OF THE HAND

When can we get away with showing the back of a hand? Not very often. In Plate 103, however, it is acceptable because the position of the child's hand is perfectly natural as she snuggles up to her grandpa. Grandpa's hands are also in a natural pose, even though they show a slight view of the back of one hand. They show masculinity and create a base for the portrait. The angle of the top hand as it meets the bottom hand also aids in the overall composition, as both are part of a leading line toward the child.

■ SUCCESSFUL HAND POSING

Leading Lines. In Plate 104, a delightful portrait of a high-school senior, the subject's elegantly posed hands help to reduce the visible area of white sweater that would otherwise be too bright for a low key portrait. The pose, showing only the sides of her hands, also creates a leading line to her beautiful smile. Had she been dressed in a darker-color sweater, this pose would still have worked because of its leading lines and because the lighting is softer than in the poses shown in Plates 100 and 101.

Classic Posing. Plate 105 is a classic example of correct hand posing. First, the lighting from the left of the portrait illuminates only the arm that is furthest from the camera; it then falls, leaving the other arm and the fingers of her right hand in shadow. Her left hand sits loosely on her right wrist. Her left arm angles slightly downward, so that the pattern formed by her arms is not square but slightly elliptical. The

hands and arms in this portrait support the radiant image of a bride.

Composition. A white-clad subject in a low key portrait is always a

Plate 104—Note how the hands have been posed elegantly, leading you to the great smile and also covering some of the white sweater.

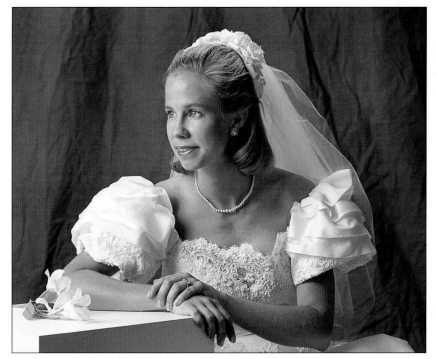

Plate 105 (left)—Note how the fingers are relaxed and gently spread over the subject's wrist. They are not gripping her arm, just resting comfortably. Plate 106 (right)—This pose of the hands makes them attractive and also creates a circle that leads back to the focal point of the portrait.

 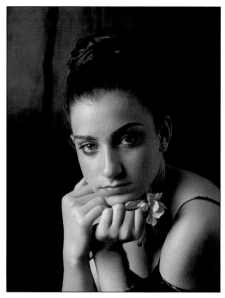

Plate 107 (left)—This is an absolute don't do *hand pose. It may have been comfortable for the subject, but it is most unsightly in a portrait. Plate 108 (center)—This was a move in the right direction but is still unacceptable. Plate 109 (right)—The near hand looks a little better but the other hand is too straight and interferes with the modeling of the far side of the face.*

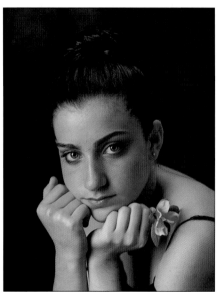 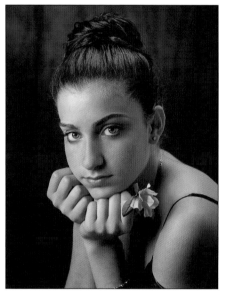

Plate 110 (left)—Both hands look a little better, but their separation from each other causes them to use up too much of the composition and detracts from the subject's lovely face. Plate 111 (right)—Note how the hands look much better and create a cradle for the face. Pushing the far hand away from her cheek allows the far side of her face to be nicely modeled.

challenge when posing the hands. In Plate 106, the college graduate's white cap and gown required that hands be posed carefully to avoid rendering them as monotone and without skin texture. In this portrait, the hands and arms were used as a circle that continuously leads you to the graduate's face. Note that both hands are shown from the side, though there is a hint of the inside of her arm that she is resting on.

The lower hand has a slight bend (in posing, often called a "break") at the wrist. This prevents it from having a "dying swan" look—the term used to describe a position in which the wrist breaks downward and is exposed to the camera in an unflattering way.

■ HEAD-AND-SHOULDERS PORTRAITS

There is always a temptation to use the subject's hands in an exotic style—especially when they are beautiful. However, hands are almost always lighter in skin tone than the subject's face and will create a lighting challenge. When the hands are used close to the face they may well be the first thing that you notice in the portrait. When they are shown against a low key background, as in Plate 107, an unflattering view of the hands will be a serious letdown in the portrait.

In Plate 107, the hand is awkwardly bent and twisted and shows her knuckles—something you should never do. In Plate 108, a significant improvement has been made, but there was still a problem. Although the hand did look much better, it still

demanded too much attention when shown against the dark background.

To continue the search for a better posing of this young lady's hands, the angle of view was changed and the other hand was brought into the pose. A flower was also introduced to add something special and help justify the inclusion of the hands.

In Plate 109, the hand nearest the camera worked quite well—but the other hand was exposed to the light, her thumb intruded into focus, and it was too straight. In Plate 110, the angle of view was changed slightly. Because they were separated though, the hands were too prominent and the thumb again intruded into the pose. Note that because one wrist was not bent as much as the other, the bones of the far wrist are not seen in a flattering style.

In Plate 111, the entire portrait takes on a much more pleasing look. The hands were brought together and both have a "live swan" look (the wrist bends up in a flattering way). Now, the hands form a base for her portrait and do not detract from the beauty of the face and eyes. Additionally, the lighting of the arms was toned down so they are a full stop darker than the illumination on the face.

■ SEATED OR STANDING WITH A CHAIR

Plate 112 shows a view of the hands that should always be avoided. The fingers should never be seen coming directly toward the camera. It is one of the most unflattering views possible of a person's hands. The view of the wrist of the other hand is equally unflattering, showing the knuckles prominently; unless your portrait is

of a boxer, this is something you will not want to do.

Sleeveless female subjects will present posing problems no matter how beautiful the dress or the subject—and when the dress has one bare shoulder, the problem is magnified. You can easily compound the problem by using a prop, such as the chair in Plate 113. The angle of view

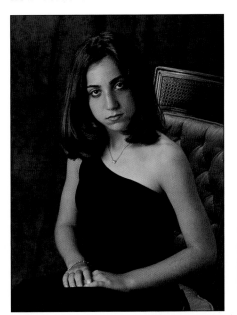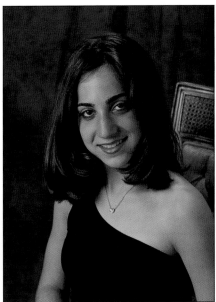

Plate 112 (left)—Everything about the arms and hands in this image is unflattering. Fingers should never be aimed at the camera, and the knuckle of the bottom hand looks ugly. Plate 113 (right)—Eliminating the hands and showing less of the arms was an improvement, but the far arm still looked kind of weird. The way the black dress separates the arm from the rest of the figure is something to be avoided.

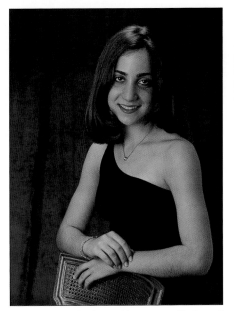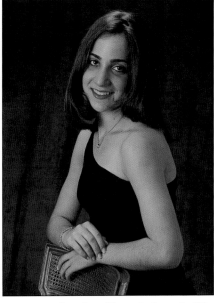

Plate 114 (left)—This was a distinct improvement, but it still needed work. The hands and arms create a circle that comes back to her face, but the hands are showing knuckles and only three fingers are visible on the other hand. Plate 115 (right)—This is not a nice way to show off the arms of a pretty girl. The near elbow looks heavy and unfeminine because it is much nearer the camera than the rest of her figure.

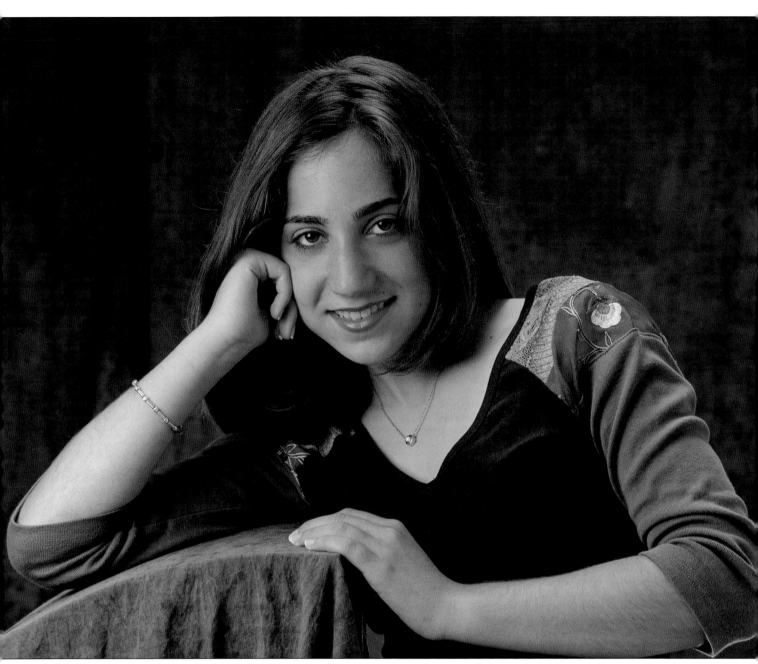

Plate 116—A different style of portrait enables you to pose hands and arms in a more flattering way. The hands are better here, but the arm supporting her face is still a little too straight. It gets by here, but wouldn't hold up under the rigorous eyes of a print competition judge.

caused the far arm to appear separated from the subject; it would be much better if it were not showing at all. Add the poorly positioned chair back, and you have a disjointed photograph—no matter how pleasant the young lady's expression.

In Plate 114 (previous page), the angle of view was changed and the chair was employed more as a sup-port to the portrait. This showed both arms and shoulders in a circular composition, with her right hand brought over her left wrist. This is a much better composition. You now see a more wholesome image of the girl—but the posing of the top hand could still be improved.

Compare Plates 114 and 115. In Plate 115, the girl turned away from the camera in a semi-profile pose, and her left arm was in a most unflat-tering position, appearing heavy and clumsy as it is rendered in relief against her black dress. Her right arm was also presented poorly, as it was separated from the rest of her figure by the black dress. In essence, what you are seeing is a portrait of a happy smiling girl that is unfortu-

nately dominated by the posing of her arms.

■ HAND TO THE CHEEK

In Plate 116, the same subject is seen in a relaxed and comfortable pose. This time the arms were placed in a

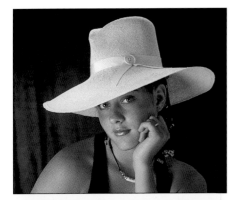

much more natural position and form a circular pattern that leads you to her pretty smile—which is what the portrait is all about. Though the arm on which she was resting her head is a little too straight and does not have the "live swan" break at the wrist, it is not unduly objectionable. This is mainly because it works in

Plate 117 (left)—The hand and arm are a little straight. Cropping out an arm draws attention to it, so it's not always a good idea. Plate 118 (below)— Note how the same pose improves when it is cropped closer to show less of the arm.

harmony with the other arm in forming the leading lines that bring you back to her face.

In a close-up portrait the use of hands can be very effective. In this type of image, the arms and hands should generally run across the composition, rather than vertically. In Plates 117 and 118, the arm and hand are used for a pleasant portrait and do add interest, but the forearm in Plate 117 is too long and too noticeable. In Plate 118, the portrait is cropped higher and the forearm is much less of a distraction. It is only a little adjustment, but it makes a significant difference.

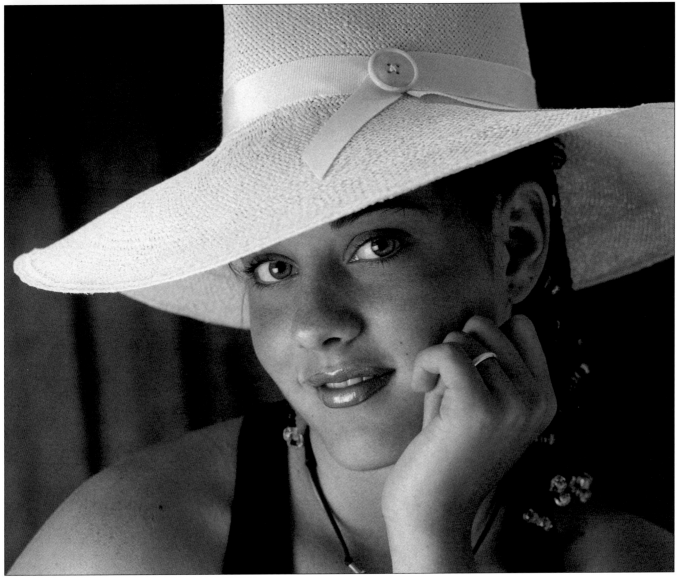

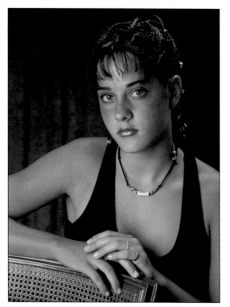

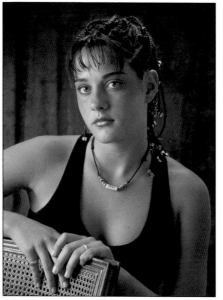

■ ARMS AS A KEY ELEMENT

Plates 119 and 120 show the bad and the better when using a chair back as a prop and using the subject's bare arms as a key element of the composition. In Plate 119, the fingers of the hand resting on the chair back were poorly spread so that they attract your attention, and the hand on top was in a very unattractive position. In Plate 120, note how the adjustments have made the use of the hands a nice addition to the portrait's appeal.

Plate 119 (left)—This is another hand pose that is not pretty. Showing only three spread fingers and knuckles never looks good. Plate 120 (right)—Here the hands are posed much better, although—when possible—you should avoid chopping off the arm.

■ CROSSED ARMS

When deciding to use hands and arms in a portrait it is important to visualize the final composition before

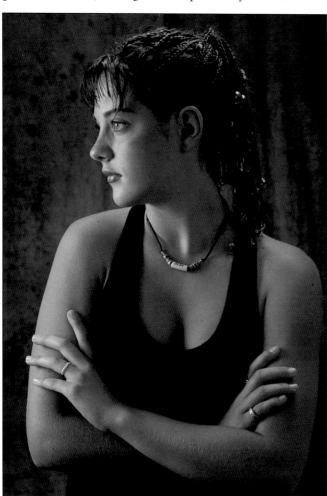

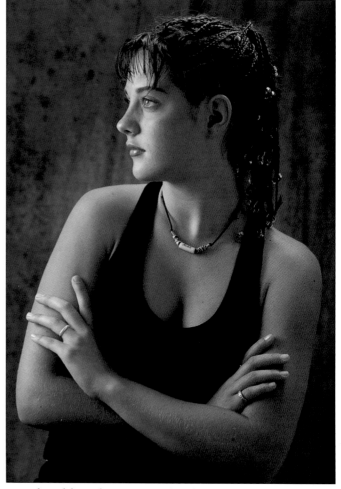

Plate 121 (left)—Note how much better the arms and hands are posed and how they create a circular composition that brings you back to the lovely profile. Plate 122 (right)—Note the difference in the expression of the girl by the way she has slightly tilted backward. It raises her head and makes her look less pensive than in Plate 121.

you pose the subject. This will enable you to create an image that has both good composition and style. Plates 121 and 122 were created with the total image in mind. The young lady's dress leaves her arms and shoulders uncovered.

Creating a flattering, slimming effect required a pose and use of the hands and arms that would reduce the focus on her limbs and draw you to her face. In both the portraits, the arms are posed to create a circular composition that leads you to a beautiful profile. She was asked to fold her arms naturally, then her hands and fingers were repositioned to look more feminine. This was achieved by spreading her fingers more loosely than she would normally position them so that they rested gently on her upper arm. The effect is delicate and looks natural even though it has been finessed.

The profile lighting set produced a 4:1 lighting ratio, causing the area of the portrait facing the camera to be in approximately the same tonal range as the shadow side of her face.

Now compare the two portraits and see the significant difference. In Plate 121, the young lady is relatively static, almost upright, and focused on something that is slightly below her eye level. This causes her to have a pensive expression. In Plate 122, she is slightly tilted toward her left shoulder, and she is focused on

Plate 123 (top)—This is an example of using hands to bring a group together and make it look more personal. Plate 124 (bottom)—In this family portrait the hands and arms of the children at each side are placed so as to bring the group together.

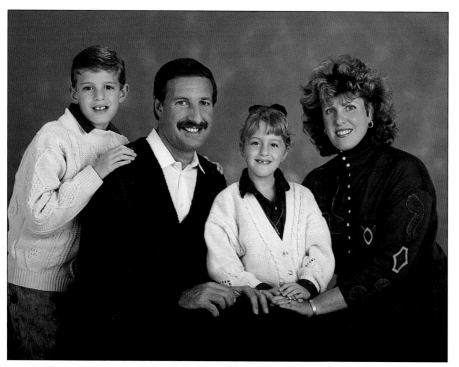

Plate 125 (left)—Linking the subjects' hands brings this family together. Plate 126 (above)—Have female subjects aim their front foot at the camera and place their other foot behind it at an angle of approximately 45° from the camera.

something slightly above her eye level. This completely changes her expression into one of interest and makes a portrait with more vitality.

■ HANDS IN GROUP PORTRAITS
For groups, consider using hands as a method of creating a connection between your subjects. In Plate 123 (previous page), the young woman at the left is connected to the group by placing her hand on the shoulder of the blond woman. The male subject at the back has his left hand on the shoulder of the young man. This not only creates a connection that brings warmth to the group, it constructively employs the bare arm of the woman in the sleeveless dress.

In the family portrait in Plate 124 (previous page), the hands of the children at each end of the group are connected in a similar manner as in the previous portrait. Because these children are wearing white and so much of the portrait is made up of deep tones, it was important that their arms not be allowed to run

straight up and down. The way they are connected helps to bring the group into a much more pleasing composition.

In Plate 125, note how the hands of all the members of the group tie them together as a family. Note too, that the hands run across the composition and create a base for the portrait.

■ FEET AND LEGS
When you are photographing girls and women in full-length poses, the posing of their legs is most important. Careless positioning of female legs is unattractive, inelegant, and unflattering. Legs and feet should be positioned so that they present a tapered view that makes: them look slim and feminine.

If you have ever photographed little girls, you will note that their legs and feet are much removed from the notion of elegance. At an early age, little girls have not learned how to look their best. As soon as they are able to understand your directions,

though, you are obligated to instruct them on how to present their form as flatteringly as possible.

When standing, have female subjects aim their front foot directly at the camera and place their other foot behind it at an angle of approximately 45° from the camera. Have them place their weight on their back foot and relax the front leg so that there is slight bend at the knee. The ladies in Plate 126 are pretty much doing just that. This presents a much more pleasing pose than if they were standing with both legs side by side, as they probably would if you did not ask them to do otherwise.

When photographing a large seated group, strive for a similar presentation. Have the women slightly angled away from the camera and have the toe of the foot nearest to the camera slightly forward of the knee. Place the rear foot slightly behind the front foot, which should be aimed almost straight at the camera, as shown in Plate 127. Though dressed for an event, this is a relatively informal group, so the posing is more relaxed than in Plate 128.

This grouping is for a much more formal family, and they are dressed in a way that requires them to be a little less relaxed. The women in the front, however, are still slightly angled away from the camera, and the hands and arms are posed correctly. Note the tapered look to the legs and that the arms and hands are close to their bodies and run across the plane of the camera. Note too that the hands of the male subjects are placed on the banister so that they are not simply dangling.

In very large groups with many women seated, you can also have the subjects cross their ankles. If you choose to do this, make sure that each female subject is slightly turned toward the center of the composition and that the front leg crosses the back leg.

Plate 129 shows the young lady almost directly facing the camera. This makes the positioning of the legs even more critical. If her legs are not correctly placed, no matter how lovely they are they will not be flattered. In this portrait, the young lady has her feet in exactly the best position so that her legs look their best.

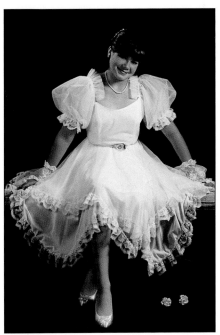

Plate 127 (top left)—Note that the ladies have one foot in front of the other so that they present a tapered view. The front foot should always be aimed at the camera. Plate 128 (bottom left)—Note both the hands and legs of the women. Legs and hands in a formal portrait should look elegant. Plate 129 (above)— In this portrait the legs are correctly posed, creating an elegant view that flatters these pretty legs.

14.
Light Ratios

Light ratios describe the difference between the amount of light that falls on the highlight area and the amount of light that falls on the shadow areas of a subject. These are expressed in proportions, like 3:1 (three times more light on the highlight area than on the shadow area) or 2:1 (two times more light on the highlight area than on the shadow area). This difference affects contrast and the rendition of detail. For instance, a 3:1 ratio will show more detail on the shadow side of the face than a 4:1 ratio.

■ CALCULATING LIGHT RATIOS

A ratio is calculated by measuring the difference in exposure between the light falling on the highlight side and the shadow side of the face. Each $\frac{1}{2}$ stop of difference equals one unit of light. Let's look at some examples:

Imagine that your main light is set to f-8 and your fill light is set to f-5.6. The main light is therefore 1 stop (or two units of light) brighter than the fill light. The fill light is always counted as one unit and added to the main light for a total of three—thus the ratio here is 3:1. If you keep the main light at

"RECOMMENDED" RATIOS

Light ratios are a frequent topic of discussion at seminars and workshops—and a subject of many questions. Often, attendees ask the presenters about the ratios in the images on display, presumably with the idea that they will use the same "formula" to create their own image later on. While the advice of another photographer may be useful for deciding where to begin when selecting a ratio, there is no reason for you to expose the portrait at the "recommended" ratio if another ratio seems more suitable for the subject in front of your camera. Flattering your subject is much more important than sticking to any preconceived ratio.

f-8 but reduce the fill light by ½ stop (to f-4.5), you will have increased the ratio by one unit, making it 4:1. This is because the difference between the main light and the fill light is now three units of light. Added to the one unit of fill light, this yields a ratio of 4:1.

■ LIGHT RATIOS FOR LOW KEY

A 3:1 ratio is very popular when working with women and children. Indeed, many photographers feel it is inappropriate to use a ratio longer (higher) than 3:1 when photographing children. However, many portraits—of both women and children—would have more depth and feeling with a 3.5:1 ratio. This is especially the case in low key, because using a higher ratio will help to harmonize the tonal range of the skin tones with the composition as a whole. To better understand ratios and their effect on your portraits, examine the following four illustrations. From left to right, these have progressively shorter (lower) ratios of 4.5:1, 3:1, 2.5:1, and 2:1.

Assuming the exposure for the main light is f-8, the fill light for Illustration 1 would be set at f-3.5. To obtain the ratio in Illustration 2, the fill light would be set at f-5.6. To achieve the ratio in Illustration 3, the fill light would be set at f-6.3. To achieve the ratio in Illustration 4, the fill light would be set to f-8. The apparent ratio in Illustration 4 is created by the angle of the main light in relation to the subject.

■ TEXTURE

Illustrations 1–4 also show how the light ratio affects the overall texture in the portrait. In Illustration 1,

Illustration 1 (4.5:1)

Illustration 2 (3:1)

Illustration 3 (2.5:1)

Illustration 4 (2:1)

there is no texture on the shadow side of the portrait because it is virtually black from the cheekbone all the way to the ear. In Illustration 4, if this were a human subject there would be good texture; with accurate focusing and exposure, you would be able to see skin tones very nicely. To explore this further, let's reexamine a few portraits we looked at in previous chapters.

In Plate 130 (next page), you will see that the portrait was created with a 3:1 ratio. Because the focusing and exposure is accurate, there is good texture in the skin tones, and

you can see the fine facial hair very clearly.

Compare this to Plate 131 (next page, which has a ratio of 5:1). As you can see, increasing the ratio beyond 4.5:1 (5:1 or longer) makes very little difference in the impact of the portrait because the shadow side of the portrait is already filled with black and lacks tone and texture.

Turn to Plate 132 (next page) for an example of a 2.5:1 ratio. As you can see, using a ratio of less than 2:1 would make very little difference—the lighting is already virtually flat.

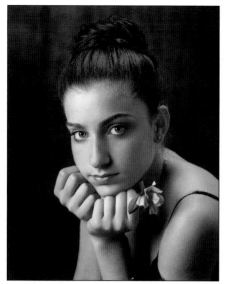

Plate 130

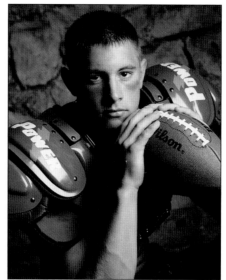

Plate 131

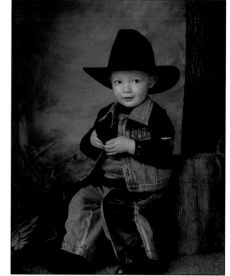

Plate 132

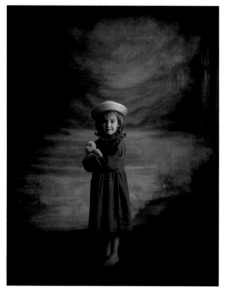

Plate 133

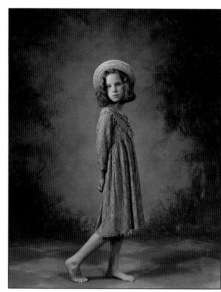

Plate 134

■ ANGLE OF THE HEAD

It is important to note the angle of the subject's head in the examples in this book—this has a major influence on the apparent ratio. If we reexamine the portrait shown in Plate 133, the girl's head was slightly turned away from the main light, which created the impression that the lighting had a longer ratio than in fact was used. In Plate 134, the girl's head was slightly turned toward the main light. This made it appear that the lighting set had a shorter ratio. In actuality, the lighting sets used for

Plates 68 and 70 were very similar, if not identical.

■ LEARNING TO USE RATIOS

Learning and practicing the use of ratios is an exercise that will pay great dividends. Here's how to get started:

Place your subject in your lighting set so that he or she presents a three-quarter head view to the camera. Determine your exposure for the main light. Let us assume it is f-8. Now dial in your fill light to the same exposure (f-8). You now have a 2:1 ratio.

Gradually reduce the power of your fill light, using the smallest increments available (in increments of ¼ stop, if possible). If this is not possible with your power head, simply move the light head gradually farther from the subject in increments of 12" so that the intensity is steadily reduced. Each time you move the fill light by this increment you are probably reducing the ratio by approximately ¼ stop. You can check this for accuracy by metering the fill light each time you move it.

As you adjust the intensity of the fill light, you will be able to see the difference in the ratio you are creating. You should record each increment on both paper and film (or by digital capture) so that you can decide which of the ratios pleases you most.

What this exercise will achieve for you is a complete understanding of the nature of ratios in portraiture. By memorizing these you will always be able to go straight to the most appropriate ratio for each of your subjects. Most of all, you will appreciate the difference that minor adjustments can make to the impact

and quality of your portraits. It is a step in the direction of seeing light. Seeing and appreciating the effects of light is the secret to successful lighting skills.

You can also practice the art of seeing light everywhere you go and in almost every situation you find yourself in, even in very low light situations. Ideally, because this book is about low key portraiture you will concentrate on people. Continually look for the light and how it models, silhouettes and rim lights the human face. When you see something that excites you, use the next opportunity you have to replicate it in your camera room.

LIGHTING BLACK CLOTHING

In order to see detail when photographing subjects in black clothing, soft lighting should be used. Hard lighting renders longer ratios and virtually eliminates shadow detail and texture in blacks and other very dark-toned fabrics and materials unless they are of a shiny or otherwise reflective material.

■ FINE-TUNING

Typically, you will start with one predetermined ratio, then modify it to create the desired effect in your portrait. In order to modify the ratios in smaller increments (less than $\frac{1}{2}$ stop), you can use one of four options. First, you can dial up or down the power of the fill light. Second, you can move the fill light either closer to or farther away from the subject. Third, you can add a modifier to the fill light to either increase or reduce its power. Fourth, you can reduce the intensity of the fill light by fitting it with an additional scrim. However, when you move the light further away from your subject or add a scrim you change the quality of the light. Be sure to take this into consideration.

15.
Metering and Exposure

There are many different ways of metering and calculating the correct exposure—in fact, almost every master of the art of creating great portraits has a slightly different technique or style of determining the exposure for their images. Many advocate that you expose for the shadow side and print for the highlights. Others advocate that you calculate your exposure for the overall lighting set and then add to the exposure to create detail in the shadows. Another technique is to decide the exposure required to create the detail you want in the shadows, then dial up your main light for the highlights. Is any one of these options better than another? Probably not—because whatever method you use, you will learn how to make it work by adjusting your exposures based on the results you get.

■ OVER- AND UNDEREXPOSURE

Overexposure. In low key, there are some important and unique considerations. For instance, overexposure in a high key image (when using film, but not with digital) can be a considerable aid to making sure that whites are clean and the skin tones have luminance against a white background. In a low key portrait, however, the same technique will almost certainly cause the balance between the skin tones in the highlight side to burn out, sacrificing texture without significantly improving the shadow detail. This is because, in printing the portrait, the highlight side will need to be burned in and the shadow side held back or dodged.

While burning and dodging can help to get the best from all the potential detail on the negative, there is a limit to which this can be done successfully. When using film, $\frac{1}{2}$ stop of overexposure is not going to be a problem in producing a fine print. Depending of the subject matter, even 1 stop may be manageable. Beyond that, the negatives will have serious limitations when

it comes to producing fine prints. In the kind of portraiture we are discussing, it is not generally recommended you overexpose by more than ⅓ to ½ stop.

Keep in mind that matters of under- and overexposure change when creating images digitally instead of on film.

Overexposure for Special Effect. Overexposing a high-contrast portrait will increase the contrast. This is because photographic printing paper will not have the capacity to render detail in shadow areas when the skin tones are printed to a realistic tonality. The overexposure will simply increase the ratio between highlight and shadow.

In a softly lit portrait, however, limited overexposure can be used to increase the detail in the shadow areas and add a little extra life to the finished portrait. This works because the softer light tends to wrap around corners.

Imagine you are photographing a bride in a white gown on a low key background and want to create a soft, sensual image. Under slightly diffused light, this subject would not print well with more than ½ stop overexposure; it would tend to flatten the delicacy of the embroidery and sequins that adorn most gowns. However, if you switch to a very soft light, you will significantly improve

the portrait by overexposing by up to 1 stop from the meter reading.

Underexposure. Correct exposure is a key element in low key, because underexposure will cause your portraits to lack shadow detail and have a loss of skin tone quality. Underexposure results in prints with a lack of life and sparkle. Highlights will be dulled and the shadows will be without detail. Some areas will appear more gray than rich in tone.

■ THE EXPOSURE METER

The best type of exposure meter is one that has both ambient and flash metering modes, a retractable cone and, ideally, a spot metering facility. This cone may be used outdoors or indoors with the cone either retracted or wholly exposed to the light. The meter should also provide you the ability to meter incident and reflected strobe light.

In the camera room (or anywhere else that you use studio flash) the most convenient means of firing the flash and camera simultaneously is with radio or infrared remote controls. In addition to eliminating cables that can be tripped over, these allow you to take advantage of a feature of many meters: the PC connection for use with a PC cord. With this setup, the PC cord is connected to the flash, allowing you to trigger the flash from the meter position. Please see Diagram 19.

■ METERING

We will examine the most popular method (and the one I recommend) of determining the exposure in the camera room. To begin, place your subject so that you have a three-quarter view of the face from the camera position.

Next, set your main light to create your highlight-side lighting pattern. For this exercise we will assume the light is at a 45° angle from both the camera and the subject. In order to calculate the correct exposure, the main light should be the only light illuminating the subject.

Main Light. Set the meter to match the speed of the film you are

Diagram 19

Diagram 20

using (or the ISO setting on your digital camera). Then, turn the meter to its flash mode with the cone recessed. With the meter positioned as close to the subject as possible, aim the meter at the main light and take a reading. Assuming that you want to expose at f-8 (this will be the aperture of the camera or lens), take a reading after each adjustment of the light until you obtain f-8. Please see Diagram 20.

Fill Light. Next, turn off the main light and set your fill light in place. Assuming the fill light power source is the same as that of the main light, is at the same distance from the subject as the main light, and that you want to use a 3:1 ratio, set the power of the fill light at half the power you have set on the main light. All things being equal, you should get a meter reading of f-5.6. If not, then make adjustments to the power of the light until you get f-5.6. When you have obtained this reading, you have a ratio of 3:1.

Hair Light. At this point, you have a two-light set and can consider whether to bring in a hair light. When you choose to use a hair light, you will need to make a judgment as to the power required. As a general rule, the power of the hair light will be the same as the main light, but you will want to make adjustments based on the color of the subject's hair. Refine the light while watching the visible effect of the hair light on the subject, keeping in mind that the brightness of the modeling light increases and decreases proportionately with the power output of the light head.

When metering the hair light, the method is the same as with your

AVOIDING UNDESIRABLE CONTRAST

It is important to your success with your clients that you memorize the exposure for each power setting. This means you will not need to meter every time you make an adjustment to the power of your lighting units. Committing this data to memory will allow you to make rapid changes so that your sessions will go much more smoothly.

other two lights. In each case, you will only switch on the light you are metering so the light from the other units does not cause you to get a false reading.

Background Light. Having set up your three-light system, you may also require a background light. This light is best metered using the reflected light or spot metering option on your meter. Take this reading by aiming the meter at the area of the background that you are lighting.

The light you direct onto your background should not be so powerful that it causes the backdrop to look much different than it did without the light falling on it. With a low key background, you need some light to create separation, but you will not want it to be so bright that it draws attention. In general, the light on the background will be set at 1 to 1½ stops less than the main light. This guideline is just a starting point, however, and you should make the adjustments that will best suit your portrait.

There are many photographers who take the meter readings as described above, but with all the lights switched on. They then take another reading from the area immediately in front of the subject, with the meter facing the camera. If you do this, the exposure will be compromised; with all the lights on, your reading may be off by ½ stop to 1

stop, depending on how powerful your fill light is. If you use this reading as your exposure, your negative will be underexposed, resulting in loss of shadow detail and skin tone quality. With digital capture, you may find that there is no usable image at all.

■ EXPERIENCE

When you have mastered the art of seeing light you will be able to make exposure adjustments based on how you wish the image to print. You will increase and reduce exposure based on what you see and not just on what your meter tells you. Because every combination of camera, camera room, lighting unit, modifier, and film is likely to produce varying results, the techniques above should be regarded as a starting point. The numbers and recommendations are not cast in stone, though they will probably be very close or right on the button. You must test each and every recommendation to ensure that you get the results you want.

*P*ortraits are intended to represent your subjects in the most flattering way possible. Therefore, the lens you use will have a significant impact on how the portrait will look. Additionally, the perspective you use will also affect the end result. The choices you make about lenses

and perspective are important because when you use an inadvisable lens and shoot from the wrong perspective, your portraits will not be as successful, and may even end in failure.

■ LENS SELECTION

In portraiture, your goal is to produce images that have balance, depth, and harmony—and show your subject in the best way possible. Your lighting set, your composition, and the expression of your subjects can easily be compromised if you use the wrong lens.

I have always advocated that you should use the longest lens available and feasible for photographing people. There are three very good reasons for this. First, the farther you are away from your subject (assuming you can still comfortably communicate with each other, of course), the more relaxed and comfortable he or she will be. Second, the perspective the camera has on the subject with a long lens will be better controlled and more flattering. Third, and perhaps most importantly, when used at the same f-stop, a longer lens will make the depth of the face from the mask (the forehead, cheekbones, nose, and chin) to the ears appear much more natural than a shorter lens.

In the medium format, lenses between 120mm and 180mm are ideal for portraits made indoors and out. The 120mm macro lens is also a very versatile lens for your portraits, allowing you to close in on the eyes of the subject in a way that the other lenses do not. For the great majority of portraits, how-

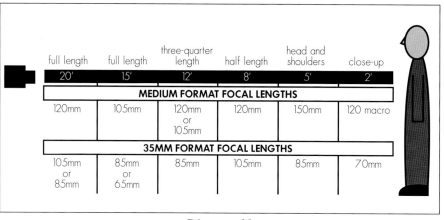

	full length	full length	three-quarter length	half length	head and shoulders	close-up
	20'	15'	12'	8'	5'	2'
MEDIUM FORMAT FOCAL LENGTHS						
	120mm	105mm	120mm or 105mm	120mm	150mm	120 macro
35MM FORMAT FOCAL LENGTHS						
	105mm or 85mm	85mm or 65mm	85mm	105mm	85mm	70mm

Diagram 21

ever, the best all-around lens is the 150mm (equivalent to an 85mm lens on a 35mm format camera).

Let's imagine that you want to create portraits of a single figure and plan for these to range from a really tight close-up all the way to a full-length portrait. Diagram 21 indicates the most appropriate lens to use when shooting at the recommended portrait aperture of f-8 (see above). The diagram assumes you are working in a room that is 20' deep and shows appropriate lens choices for each style of portrait throughout the potential 20' distance from camera to subject. Since every camera system has its own limitations in regard to the availability of lenses, one or two choices are given in some of the recommendations. You will note, however, that none of the choices include the camera's standard lens (50mm for the 35mm camera format, and 75–80mm for the medium format).

■ **APERTURE**
The iris setting, or f-stop, is also a critical consideration. Unless you are photographing a large group that is two or more subjects deep, you should avoid using an aperture smaller than f-9.3 (between f-8 and f-11)—especially in half-length and closer portraits. In close-up portraits, an aperture between f-5.6 and f-8 is most appropriate.

Indeed, portraits exposed with the lens wide open are often perceived as the most personal and flattering. This is because the narrow depth of field makes the eyes of our subjects the focal point of the image, telling us much more about who they are. In a portrait made using a smaller aperture, say f-16, the eyes and ears will appear almost on the same plane, reducing the emphasis on the eyes. When you view a portrait, it is the eyes of the subject that you should be drawn to—not the ears.

If you review the images in this book, you'll find that many were created with the lens wide open—at aperture settings as wide as f-2.8. Many of my own favorite images were created with this wide-open lens aperture, and I recommended trying this lens setting.

■ **DEPTH OF FIELD**
Many photographers are overly concerned about depth of field. The only time that depth of field in a portrait is a serious consideration is when the group is two or three people deep. However, even in these cases, there is a better way to hold all the figures in focus. Very slight adjustments in the angle of view can increase your depth of field and allow you to hold the portrait elements in focus.

Instead of closing down the aperture to obtain a greater depth of field, you can shoot from a slightly higher angle and tilt the camera very slightly downward. This changed perspective will make the plane of the film relate more closely to the depth of the group and ensure that all the subjects are in focus.

You can also refine the apparent depth of field by moving your camera slightly to one side and realigning the point of focus. You can test this method by having your subject pose in a three-quarter facial pose, then slightly changing the angle of the camera and realigning the lens focus. As you do this, watch how different aspects of the face can be brought into focus.

■ **FOCUS**
When you focus on any given point in a portrait, the total range of sharpness in the depth of field will fall one-third in front of and two-thirds beyond the point you are focusing on. If you examine your lens, you'll notice a white mark on each side of the indication of the current f-stop. These indicate the depth of field at that aperture. With a 150mm lens on medium format (85mm on 35mm format), an aperture of f-8 provides a depth of field of approximately 10" when the camera is positioned for a head-and-shoulders portrait.

To ascertain how the depth of focus will affect your portrait, divide the total depth of field by 3. If the depth of field is 10", this means that

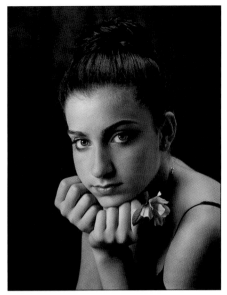

Plate 135

Plate 136

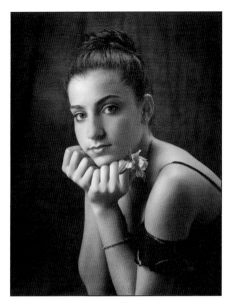

Plate 137

approximately 3.3" in front of your point of focus and about 6.6" beyond your point of focus will be in focus. However, when creating portraits, this should not be a consideration; you will focus on the most important element in the image—in most cases, the eyes.

Consider this in relation to the width of a subject's face in a three-quarter view. While you want both eyes to be in focus in your portrait, you also want to be able to see texture in the skin tones nearest to the camera. In this example, the total depth that you will want to have in focus almost matches the depth of field available. What these numbers also tell you is that your point of focus in this portrait should be the inside corner of the nearest eye. This will use the total depth of field available and bring the entire face into focus.

At wider apertures, the depth of field will be smaller. If you open up by ½ stop, you will reduce the depth of field by as much as 15%, making your point of focus even more critical. If you move the camera closer to the subject, the depth of field will also become shorter.

Depth of field is an important consideration in portrait composition, especially when there is a background that must be controlled in order for the portrait to be successful. You should choose to use the aperture that will make the best portrait, not just the one that is most convenient. If needed, you can slow down or speed up the shutter speed so as to use the best depth of field for your point of focus. This will place your subject in the ideal focal point in your composition and cause the other elements within the portrait to play a supportive role, rather than competing with the subject for the viewer's attention.

■ PERSPECTIVE

Perspective is the angle and height of the camera lens as it relates to the subject. It is a control used by the best portrait photographers to obtain superior results. If you fail to use perspective creatively, you will photograph all your subjects almost identically. As a result, you will prob-

ably also become quite bored. Using perspective creatively will allow you to break away from the norm and create portraits that are much more exciting and striking. Again, we'll return to some images used in previous chapters to evaluate the use of perspective.

Plate 136 was exposed at f-9.3, midway between f-8 and f-11. The subject's ear is in focus, but it is not as sharp as the eyes, which dominate the portrait. This f-stop is the smallest you should consider using for a portrait as close up as this.

Compare this to Plate 137, which was exposed with a larger lens aperture. Note how the child's eyes are in clear focus, despite the use of diffusion. Note too that the child's hands are also in focus. This has more to do with the perspective of the lens than the depth of field since, as you will note, the child is looking slightly up at the camera—meaning the camera was above her eye level. To give the portrait this look, the camera was slightly tilted forward, bringing both the hands and the eyes into clear focus. Note too, how the

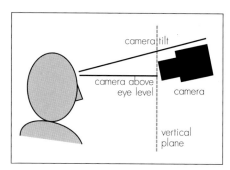

Diagram 22

wide aperture has caused the background to become blurred, an effect that is enhanced by the use of diffusion. Please see Diagram 22.

Perspective has a significant impact on the expression of your portraits. Having analyzed Plate 135 from a depth-of-field point of view, now note the difference in Plate 137. The perspective of the camera lens is distinctly different in each portrait. The perspective used in Plate 135 has the camera positioned slightly above eye level, causing the girl to look up with a much more innocent and soft expression. In Plate 137, the camera is at a lower perspective, very slightly looking up at her eyes from approximately nose level. Instead of the innocent expression, you now see one that is more sophisticated. This expression is enhanced by the contrast between her skin tones and the low key background.

The perspective used in Plate 138 helps to illustrate the smallness of the child in the low key setting. With this perspective, the photographer also used the dark foreground to increase the low key base for the little child. This use of perspective is very effective in utilizing the available scene in which a portrait is being created.

The perspective in Plate 139 is very different. In this portrait, the child is a very independent little

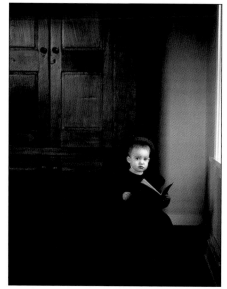

Plate 138

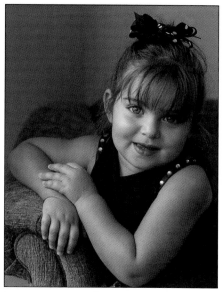

Plate 139

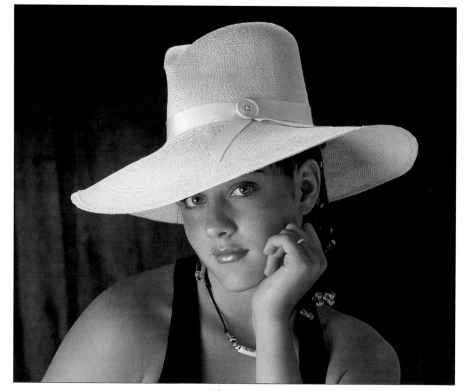

Plate 140

character with an engaging smile and the ability to assert herself. At the same time, she is a little chubby and cherubic. The portrait needed to show these traits, so the lens was aimed almost directly at her eyes, at eyebrow level, so as to cause her to raise her eyes ever so slightly. All her delightful persona has been captured with this choice of perspective.

Plate 140 shows a pair of beautiful eyes under a hat. To obtain this expression, the camera lens was at the height of the young lady's nose and upper lip. This gives us a slight view of her nostril, but the perspective pleasantly renders her nose and her pretty mouth, so it is not detrimental to the portrait. To get this expression, the girl was asked to look

at the photographer (or slightly above the camera) and not at the camera directly.

To see a variation in impression created by perspective, look at the difference between Plates 141 and 142—both profiles. One is an eight year old at the time of her first communion and the other a fifteen year old. One subject is small and very childlike, the other is a more mature young lady. The perspective of the camera was used to ensure that the girls were represented differently. For the eight year old, the lens was at her eyebrow level with just a very slight tilt downward that helps provide a more childlike view. In the portrait of the fifteen year old, the camera was midway between her head and her arms, causing the view of her to be slightly upward. This provides a view of her that suggests a more confident young lady, someone emerging into womanhood. This impression is enhanced by the very slight tilt of her body and the angle of her head as it relates to her shoulders.

Plate 143 shows a boy in a hall surrounded by earlier portraits of himself. The concept of this image was to show the boy in what is essentially an area dedicated to his growing-up process. The portrait could have been made with a wide-angle lens to show much more detail in the portraits on the walls. But to do so would have required an exposure that would have lightened up the area and removed it from low key. Instead, I selected a 75mm lens on a medium format camera. The perspective is crucial to the success of the portrait, as it must control the verticals and horizontals and, at the same time, show the boy in just the right place in the composition. Had I used a longer lens, the size relationship between the boy and the height of the hall would have been lost. The reduced area of coverage would have defeated the concept of the portrait.

In Plate 144, a 150mm lens on a medium format was used. A close and careful examination of this portrait shows that the lens was positioned so that it looked down very slightly at the child and she looked up very slightly toward the camera. Having her eyes so slightly raised creates an impression of her as a soft and gentle subject. It is a very slight adjustment from a straight-on camera-to-eye perspective, but one that is very effective in creating the desired impression. It was also important in this portrait to keep the verticals of the window opening perfectly straight in the portrait. Therefore, the camera had to be carefully positioned or it would have distorted the shape of the window, which would have been irritating to the discerning viewer.

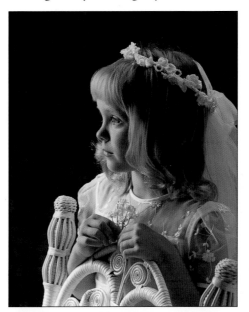

Plate 141

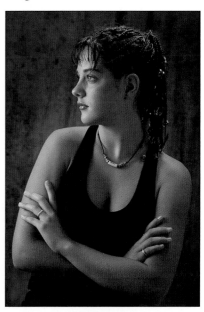

Plate 142

Plate 143

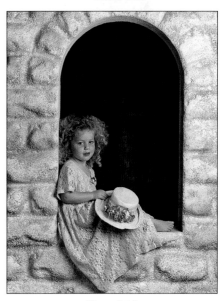

Page 144

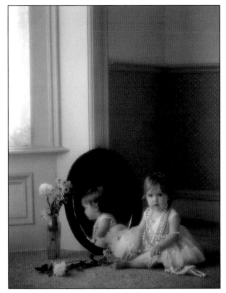

Plate 145

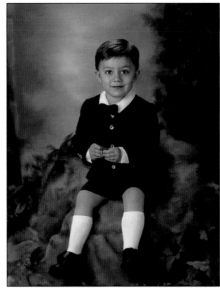

Plate 146

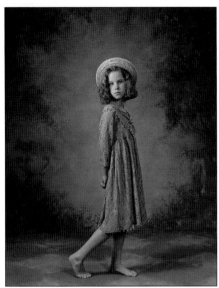

Plate 147

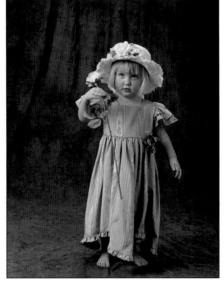

Plate 148

being superior. This is partly due to the low position of the camera that causes her to look down at the photographer. The camera position and the pose combine to create this expression. Just the opposite is the case in Plate 148, where the portrait shows both the innocence and the size of the child. This was achieved by positioning the camera slightly above her head and tipping the lens down to look directly into her eyes as she looked upward to her mother, who was just off-camera at the left. This impression of very small innocence would have been lost if the camera had been set at the child's eye level.

The *Cabaret* portrait, seen again in Plate 149, shows four children of different heights. *Cabaret* is a somewhat somber story, and the concept behind this portrait was to create that impression. Had the group all been looking directly at the eye-level camera, it would have diminished the impression. Only the youngest member of the group is looking straight at the camera, while the others are looking down—almost as if they were looking down from the theater stage. This perspective dramatically increases the serious tone.

From these observations, you will appreciate that your perspective plays a major role in the impressions created in your portraits. Each portrait that you create requires you to decide on the impression you want it to convey to the viewer. An understanding of *who* you are portraying and *for whom* you are creating the portrait will influence how you choose to make the portrait. You should seek to make each portrait as individual and unique as possible.

Creating Plate 145 involved issues similar to those seen in Plate 143—a small child in a room with verticals and horizontals that needed to be held correctly. Here, the camera position is low so that the scale of the child in relationship with the room emphasizes how small she is. The perspective is just right. Another choice of lens would have changed the whole concept of the portrait. While the desired composition was achieved, the child was also kept very clearly in focus, and you can see the expression of slight curiosity.

In Plate 146, the photographer chose a lens perspective that is about level with the boy's nose. The impression created by his position in the portrait is that he is very comfortable in his surroundings. Note how his eyes appear to be looking slightly above the lens. There was no need to consider the effect of this perspective on the background, since there were no verticals or horizontals to be concerned with.

In Plate 147, the girl has a most interesting expression—almost disdaining, perhaps an early sense of

■ DISTORTION

As you practice with perspective, keep in mind your lens selection. The closer you are to the subject with the shorter lens, the more the nose and the ears will grab your attention. With the longer lenses suggested above, the nose and ears will appear normal at each distance from the subject. Moving to an even longer lens will result in a loss of focus through the depth of the face—if the ear is showing, it will be so out of focus that it will not present a natural impression. These very long lenses would, however, be perfect for longer-range portraits—although you would need to stop down to create the same depth of field and perspective you'd get when working closer with a moderate telephoto.

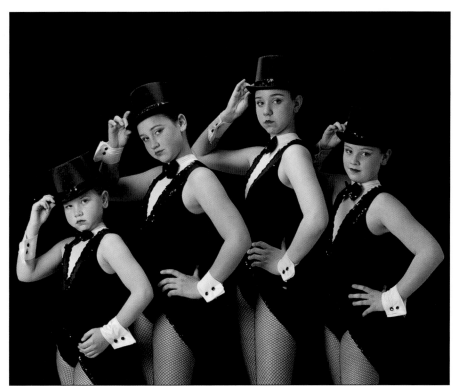

Plate 149

17.
Location Portraits

When on location portrait assignments, you will often be confronted with backgrounds and lighting patterns that are inappropriate for your low key portraiture. These situations require either subtractive lighting techniques or the use of supplementary lighting.

■ INDOOR PORTRAITS

In a client's home, you may want to create your portrait using available light in a specific location—but then find that the background is too light for low key (i.e., the exposure ratio between the subject and background is very low). To make this location work, you will need to find a way to reduce the brightness of the background, or increase lighting on the subject. This will lengthen the ratio between the subject and background.

Subject Position. The first option may be to move the subject as far from the background as possible and as close to the light source as is practical. This may reduce the light ratio between the subject and background by 1 stop.

Blockers. Subtractive lighting techniques can be used for more dramatic modifications. This requires you to use blockers that will reduce the intensity of the light on the background while leaving the light falling on the subject unaffected.

There are two main methods of achieving this objective. The first is to use blockers (panels or opaque reflectors) to narrow the light source. If you are fortunate, you may have curtains or drapes at the window that you can use to adjust the light source. By narrowing the light source, you will reduce the light on the background but not that on the subject (provided that you slightly angle the camera view, directing it at area of the background that is

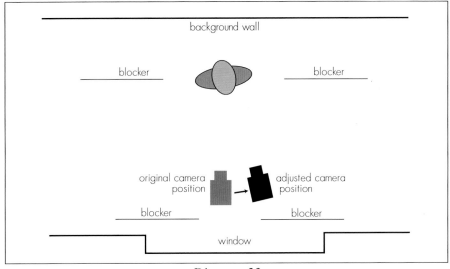

Diagram 23

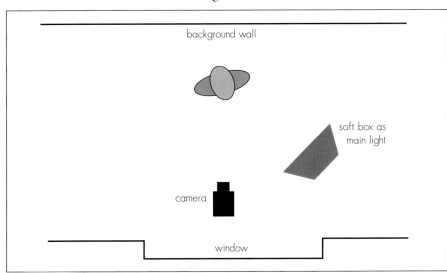

Diagram 24

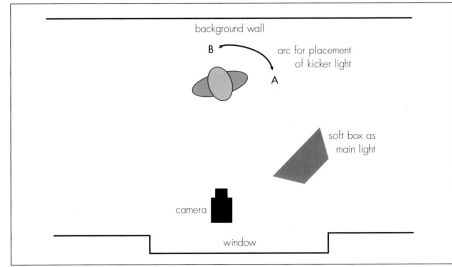

Diagram 25

now shaded from the light). You can think of this in the same terms as working in the camera room with a strip light or a soft box with opaque strips attached to reduce the width of the light source. See Diagram 23.

Alternately, you can position the blockers at the same distance from the background as the subject and adjust them to achieve the light pattern you want. The blockers may be maneuvered in different configurations until they create a low key background while still retaining suitable lighting on the subject. This may mean you will angle each blocker differently or have one closer to the subject than the other. In this position, close to the subject, you will probably not have to compromise your original camera position.

Window Light as Fill. Another method for subduing the background is to use the available light as your fill light and bring in a lighting unit with the appropriate modifier for use as your main light. For example, if the available light gives you a reading of f-5.6, you could set the power of your main light at f-8 to create a 3:1 lighting ratio. This will automatically make the background at least 2 stops darker (f-4) in your finished image than it appears at the time you make the exposure. See Diagram 24.

This is a very flexible method of creating lighting sets. There may also be times when you decide to use more than one additional light source, such as a kicker. On location, this can be a small slave unit on a mini stand with a blocker positioned between the slave and the background to prevent unwanted spill. When the kicker light is at the top of

the arc, as indicated in the diagram, you will need to use an additional blocker to prevent the light from striking the camera lens.

The placement of the kicker light may be at any point in a specific arc that would be slightly behind the plane of the subject. The important point to bear in mind is that you should not be able to see it from the camera position, or you will have glare in your composition. The second important point is that the kicker light should not emit more than $\frac{1}{2}$ stop more light than the main light or it will be too bright and unbalance your lighting pattern. See Diagram 25 (previous page).

Dragging the Shutter. It is fairly common to encounter situations in which the window light in a room is not adequate for an exposure that would create form and depth. This would be a situation in which the available light reading at the background is perhaps no better than $\frac{1}{15}$ second at f-4.

This is a situation in which you will light the subject using modified flash for both your main light and your fill light—just as you would in the camera room.

Instead of exposing at the maximum shutter speed that will synchronize with your flash, however, you will expose at the $\frac{1}{15}$ second exposure indicated by the metered reading of the background. This is termed "dragging the shutter." Most flash synchronization is at $\frac{1}{60}$ second, on other cameras it is as slow as $\frac{1}{30}$ second, and on lenses with Compur shutters you'll find much faster synchronization speeds.

Setting the shutter slower than the flash synchronization speed while using the flash is termed "dragging the shutter."

A typical situation in which this method can be useful is when taking a bridal portrait in a church aisle where the ambient light is inadequate for a successful portrait, but detail on the background is desirable. Often, the ambient light in such a situation would require an exposure of $\frac{1}{2}$ second to record the background in full detail. In this situation, for the portrait to hold in low key, an appropriate shutter speed would be $\frac{1}{8}$ second. This will record subdued detail on the background.

A common mistake when seeking to record a background in this way is that the photographer uses an f-stop greater than the meter reading, then attempts to print in the subject and hold back the background. This is being done more frequently with Adobe® Photoshop®, but it is not as successful as the aforementioned method.

■ **OUTDOOR LIGHTING**

Portable Flash. Many outdoor portraits will be created with portable flash. There are numerous portable flash systems, which are lightweight and convenient for location work. These can also be employed as a substitute for the camera-room system.

The drawback with these is that they do not come with the same array of modifying attachments. With the use of reflectors, attachments that fit over the flash tube to diffuse the light, and other innovative tools, however, these can perform well. Using a diffuser over the flash head will produce a wide angle of coverage that could compromise your intended lighting pattern. For this reason, it's often better to soften the light from a portable flash using scrims that can be placed just where you want them. These are available as disks and come in various sizes. You can also obtain large scrims that are supported by frames made of modular plastic or light metal. With either of these options, you place your portable flash behind the scrim so as to produce the diffused light needed for your portrait.

Among your other tools for location shoots, you should also have a reflector that you can bounce your portable flash onto. One type of reflector that is not often considered is a deep umbrella. The deeper the umbrella, the better the control you will have over the light.

Matching the Light. When adding flash to natural light outdoors, the light source used will need to be controlled to make the portrait look like only natural light was used. To achieve this, you must first identify the light pattern that the natural light creates on the subject, then position your main light in harmony with it. Then, analyze the light so that you match the color and type of light (i.e., warm or cool, soft or flat).

If the light is warm, then you can use a warming filter on the camera lens or a warming gel on the flash. You shouldn't need a separate fill light in most situations, but if you do, it must match the color and contrast of the main light.

Separation. Imagine a scene in which the light is low, soft, and flat—and a desirable background is available for your portrait. In this scene, the available light reading is $\frac{1}{60}$ second at f-2.8. This exposure will produce a well-exposed negative that will also have a low key background. In such a scene, consider adding a diffused kicker light that will give you an exposure of f-4, then expose at the ambient light meter reading. The result will be a portrait in low key that has a separation from the background.

18.
Style and Individuality

*W*hile there are a multitude of shirts and dresses to try on in the local mall, some will appeal to you infinitely more than most of the others. This is because each offers a different style. In much the same way, different styles of images excite our senses. These same senses will eventually define what kind of photographer you will be. As you peruse the images in this book, some will evoke more excitement than others. As you analyze those that appeal to you the most, you will be defining your style.

■ INDIVIDUALITY

The work of five photographers (in addition to my own) is featured in this book. As you look at these images, you will detect that each artist has a certain underlying style—even if there are variations over the range of portraits that they have created. To get the style they have settled into, they doubtless went through a process of learning the techniques that make them accomplished photographers.

Robert (Bob) Summitt. Robert (Bob) Summitt's images are characterized by deep and thoughtful character portraits, and he uses low key to emphasize the mood of his subjects. He also uses space to accentuate this mood. His use of deep tones, the essence of low key, is very effective. You will also observe that he uses split lighting techniques that force you to peer into the one eye that is looking at you, creating an instant connection between you and the subject. All his images seem to have a melodramatic feel to them.

Edda Taylor. Edda Taylor's mother-and-baby portraits show her flair for capturing subtle skin tones and exquisite harmony. It would be difficult to imagine these images being in any other key. She uses the subdued or dark

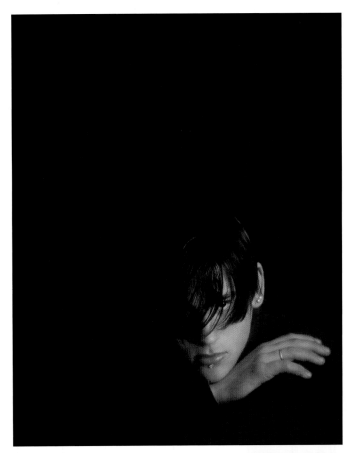

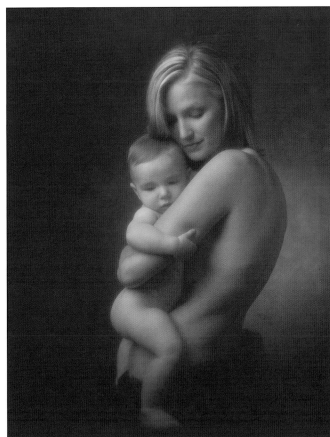

Top left—Photograph by Robert (Bob) Summitt. Top right—Photograph by Edda Taylor. Right—Photograph by Dennis Craft.

backgrounds as a base for her delicate lighting style. Each of these portraits uses the background in a subtly different way. Notice how cleverly she has placed her subjects against the background so as to create a delicate separation. This is a style much more difficult to emulate than any of the others in this book. But there is no reason why you should not try.

Dennis Craft. Dennis Craft frequently uses diffusion in his unique portrait style. His images have an ethereal feel to them—it's like he creates a little fantasy for each of his subjects. While the use of diffusion can be effective in any key, it is a perfect tool to use in low key because it helps to smooth out and blend the

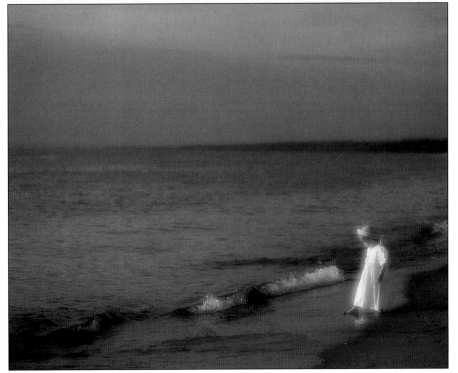

darker backgrounds used in this key. You will also note his use of props. His keen sense of design makes their placement and use in his compositions truly excellent. The portrait of the boy at the computer, in what appears to be an old building or barn, is one in which he did not use diffusion. In that image, lighting was used to create a natural impression,

Left—Photograph by Jeff Lubin. Right—Photograph by Kim and Peggy Warmolts.

and it is exceptionally believable. Normally, we might not think of using our computer in this low key environment, but it is brilliantly done.

Jeff Lubin. Jeff Lubin is a photographer whose lighting techniques and skills are among the best in portrait photography. His work tells you that he is a perfectionist, and that's a quality he has built his reputation on. Each of his portraits demonstrates the subtle use of four or more lights. They are so seamlessly lit that it's hard to detect any individual light sources other than the main light. When it becomes difficult to detect each light used in a composition, you know you are seeing an expert's work.

Kim and Peggy Warmolts. Kim and Peggy Warmolts produce many storybook portraits and put a great

deal of thought into their compositions. Their primary style is designed to show their subjects at their best and tell a story at the same time. This is an excellent way to create a style that will be recognized by your market and build a profitable reputation.

Others. Other renowned photographers, such as Monte Zucker, Philip Charis, Al Gilbert, Don Blair, and William Macintosh have all distinguished themselves with an individual style. Monte Zucker's work, for instance, exemplifies painstaking precision lighting and an advanced mastery of posing. His work is instantly recognizable. Portraits by Philip Charis are simply elegant. It is impossible to imagine his work in any other than low key. His props and backgrounds are totally harmonious with his subjects and are just as elegant. I have heard it said that his

style is so simple that anyone can do it—but no one has successfully produced portraits in a style similar to his. The style tells you as much about Philip Charis as it does about his subjects. It is what style is all about.

■ YOUR OWN STYLE

If you want to create a niche in your marketplace, settling on a style is crucial. No matter how accomplished a photographer you are, you cannot be everything to everyone. You need to attract those people in your market who most appreciate your particular style. This is called market focus and it is a key to your success.

ow key portraiture is a classic style that is easily recognized by both your fellow photographers and the majority of the public. But many of the images you see created in this style are rather ordinary—not exciting or of great interest. The portraits shown in this book demonstrate not only style but a unique quality that a discerning public will appreciate. While I am not advocating that you seek to copy any one of the styles illustrated, you are encouraged to practice the techniques and methods explained. You will find that some of them will become a constant tool in your photographic arsenal. But whatever style you decide on, you will have learned techniques that at some time or another will be most useful.

This section outlines and illustrates the lighting equipment discussed in previous chapters.

Illustration 1 shows a soft box with a white interior that has a diffusing scrim attached to the front. This configuration will take the hard edge off the

Illustration 1

light and provide a slightly softer light that is more suitable for portraiture. It also has a second scrim that can used to further diffuse the light. When this second scrim is in place, the light is most suitable for low key portraits.

You can also cover the interior of the box with an 18% gray material. This will produce an ultra-soft light that will virtually wrap around the subject when properly placed and reduce the need for a separate reflector or fill light.

Illustration 2 shows how the soft box in Illustration 1 can be modified. There are three different attachments that may be fitted to the soft box.

There is a black modifier that creates a round light source. This yields a circular catchlight in the subject's eyes and limits the close-up coverage of the light when a vignette is desirable.

The attachment with a series of strips is a louver. This attachment assists in controlling the light, preventing light scatter and directing

Illustration 2

the light more precisely. This attachment is ideal for profile portraits.

There are also two black strips, each equal to one-third of the width of the light box. These are used to narrow the light source. They may be used

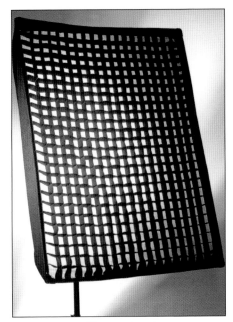

Illustration 4

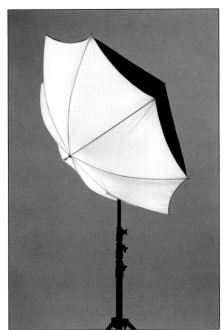

Illustration 5

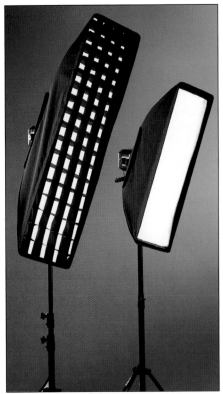

Illustration 3

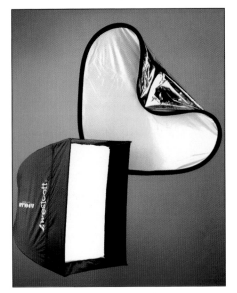

Illustration 6

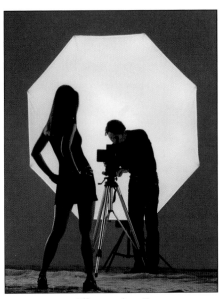

Illustration 7

Illustration 8

singly or jointly, depending on the coverage required. When used together they produce a similar coverage as the strip bank as shown in Illustration 3.

Illustration 3 shows examples of strip banks, which provide a narrow light source that is a little different than using the box illustrated in Illustration 2. The spread of the light is a little tighter, because the box itself is narrower. The attachment on one of the light banks is called an egg-crate grid, which will increase the control of the light and reduce its spread.

Illustration 4 shows a honey-comb-style grid that is attached to a soft box. This grid will control a large light source, preventing light scatter over the composition. The grid will also prevent glare when there are shiny objects within the portrait composition.

Illustration 5 shows the Halo by FJ Westcott. It is basically an umbrella with a reversed umbrella-shaped scrim in front. It produces a softened umbrella-style light that is a little hotter in the center with a 10% to 15% falloff at the edges. It is suitable for both close-up and full-length portraits. For a group that is not adequately covered by the main light, the Halo can be bounced off a wall at the side of your lighting set or feathered toward the group to even out the light coverage.

Along with another view of the Westcott Apollo, in Illustration 6 you see a collapsible reflector with silver on one side and soft white on the other. The silver side would be used when slightly harder reflected light is preferred. The white side is more compatible with soft-box lighting styles.

Illustration 7 shows the unique Westcott Octabank Box. This is an excellent 72" modifier perfect for situations where a large, soft light source is required. It can be used on location to produce a light that is very close to that of window light. It packs away into a carrying case and can be assembled in a few minutes.

Illustration 8 shows the large frame-supported grids that can be used with the Octagon Box for greater control and modification of the light.

Barn doors—Black, metal or fiber folding doors that attach to a light's reflector. Used to control the width of the beam of light.

Blockers—Panels used to prevent light from falling in areas where it is not wanted.

Blown out—A term used to describe overlighting the highlight side of the subject's face by the modeling light so that it is not possible to render form and skin tones.

Bounce flash—A method of flash lighting that uses bright surfaces to redirect the light.

Box light—A diffused light source housed in a box-shaped reflector. Such lights have a range of different interior materials that produce different qualities of light.

Burned out—A term used to describe gross overexposure of the entire image that prevents producing a balanced print with skin tones. Similar to "Blown out."

Butterfly lighting—One of the basic portrait lighting patterns, characterized by a high key light placed directly in line with the subject's nose. Under the nose, this produces a butterfly-shaped shadow that does not spill onto the opposite side of the face.

Catchlight—The specular highlights that are reflected in the pupil or iris of the eye. Caused by the main or fill lights.

Composition—Designing of an image. The arrangement of elements in a photograph.

Cookie—An insert placed in front of a spotlight that has patterns that are projected onto a background.

Feathering—Deliberately directing light so that the edge (not the center) of the beam illuminates the subject. This influences the light ratio.

Fill light—Secondary light used to fill in the shadows created by the main light. Also influences the light ratio.

Flag—An adjustable square or rectangular panel that is clipped onto the light reflector.

Flat lighting—A light source or style that produces little or no modeling of the face.

Gobo—Light-blocking card that is attached either to the light reflector, or supported by a boom or stand.

Guide number—Number used to rate the power of studio and portable flash units. You can determine the flash output at a given distance by dividing the guide number by that distance.

Hair light—A light placed over a subject to provide detail in the hair.

High key—Type of lighting used to create a light ratio by high-lighting one side of the face and creating a desired density of shadow on the opposite side.

Key light—The light that defines the shape of the subject. Also called the main light.

Kicker light—A light placed behind or to the side of a subject to highlight the hair or contour of the figure.

Lighting key—Defines the overall tonal range of a portrait.

Lighting pattern—Lighting designed to create the shape or modeling of the subject.

Light ratio—The difference between the intensity of the main light, which highlights one side of the face, and the fill light, which reduces the intensity of the shadow on the opposite side. High ratios are described as long, low ratios are described as short.

Loop lighting—A portrait lighting pattern characterized by a loop-like shaped shadow under the subject's nose caused by the main light.

Low key—An image that has significantly more dark tones than light tones.

Main light—The light used to create a lighting pattern that defines the subject. Also called the key light.

Middle key—An image in which the tones are neither significantly dark, nor significantly bright. The tonal range is midway between dark and light.

Modifier—An accessory used to change the quality of illumination from a light source.

Portable flash—A flash unit or kit with independent power that may be carried and used without the use of a stand or tripod.

Power point—A point within a composition where two of the vertical and horizontal lines of thirds converge.

Profile lighting—A lighting pattern that creates a defined side view of the subject's face.

Reflector—A white, gold, or silver card, disc or panel used to redirect light onto the subject. Also, an attachment to the lighting unit used to control the spread of light.

Rule of thirds—According to this rule of composition, the image frame is divided into thirds, both horizontally and vertically. The points at which these lines cross are called power points, and are considered strong points at which to place the subject of your image.

Scrim—A fabric panel placed between the light source and the subject to modify the light.

Separation—The use of lighting or background design that allows the subject to be presented in relief against the background.

Soft lighting—Lighting style that produces a relatively short light ratio.

Specular—An unmodified (or partially unmodified) light source. May also be described as hard.

Specular highlights—Sharp, dense image points on the negative. These appear as bright spots in the print.

Split lighting—Portrait lighting that renders the subject in two distinct areas in which one side of the face is cast in shadow that is wholly or virtually without discernable detail.

Subtractive lighting—Lighting technique that uses a black card or panel to block light from an area in order to better define the light ratio.

Umbrella lighting—Refers to modifying the light by using an umbrella modifier.

Washed out—An area of an image that is overexposed and lacks detail and texture.

Wraparound lighting—A soft type of light, produced by umbrellas and other types of modifiers, that hits both sides of the subject, producing a short ratio and a relatively bright overall image.

Index

By the same author . . .

Lighting Techniques for High Key Portrait Photography

Learn to meet the challenges of high key portrait photography and produce images your clients will adore. $29.95 list, 8½x11, 128p, 100 color photos, order no. 1736.

Outdoor and Location Portrait Photography
2nd Ed.

Jeff Smith

Learn to work with natural light, select locations, and make clients look their best. Packed with step-by-step discussions and illustrations to help you shoot like a pro! $29.95 list, 8½x11, 128p, 80 color photos, index, order no. 1632.

Wedding Photography
CREATIVE TECHNIQUES FOR LIGHTING AND POSING, *2nd Ed.*

Rick Ferro

Creative techniques for lighting and posing wedding portraits that will set your work apart from the competition. Covers every phase of wedding photography. $29.95 list, 8½x11, 128p, 80 color photos, index, order no. 1649.

Professional Secrets for Photographing Children
2nd Ed.

Douglas Allen Box

Covers every aspect of photographing children, from preparing them for the shoot, to selecting the right clothes to capture a child's personality, and shooting storybook themes. $29.95 list, 8½x11, 128p, 80 color photos, index, order no. 1635.

Family Portrait Photography

Helen Boursier

Learn from professionals how to operate a successful studio. Includes: marketing family portraits, working with clients, posing, lighting, and selection of equipment. Includes images from a variety of top portrait shooters. $29.95 list, 8½x11, 120p, 120 b&w and color photos, index, order no. 1629.

Studio Portrait Photography of Children and Babies, *2nd Ed.*

Marilyn Sholin

Work with the youngest portrait clients to create cherished images. Includes techniques for working with kids at every developmental stage, from infant to preschooler. $29.95 list, 8½x11, 128p, 90 color photos, order no. 1657.

Professional Secrets of Wedding Photography
2nd Ed.

Douglas Allen Box

Top-quality portraits are analyzed to teach you the art of professional wedding portraiture. Lighting diagrams, posing information, and technical specs are included for every image. $29.95 list, 8½x11, 128p, 80 color photos, order no. 1658.

Photographer's Guide to Shooting Model & Actor Portfolios

C J Elfont, Edna Elfont, and Alan Lowy

Create outstanding images for actors and models looking for work in fashion, theater, television, or the big screen. Includes the business and photo techniques you need! $29.95 list, 8½x11, 128p, 100 b&w and color photos, order no. 1659.

Photo Retouching with Adobe® Photoshop®
2nd Ed.

Gwen Lute

Teaches every phase of the process, from scanning to final output. Learn to restore damaged photos, correct imperfections, create realistic composite images, and correct for dazzling color. $29.95 list, 8½x11, 120p, 100 color images, order no. 1660.

Storytelling Wedding Photography

Barbara Box

Barbara and her husband shoot as a team at weddings. Here, she shows you how to create outstanding candids (her specialty), and combine them with formals (her husband's specialty) to create unique wedding albums. $29.95 list, 8½x11, 128p, 60 b&w photos, order no. 1667.

Infrared Portrait Photography

Richard Beitzel

Discover the unique beauty of infrared portraits, and learn to create them yourself. Included is information on: shooting with infrared, selecting subjects and settings, filtration, lighting, and much more! $29.95 list, 8½x11, 128p, 60 b&w photos, order no. 1669.

Marketing and Selling Black & White Portrait Photography

Helen T. Boursier

Complete manual for adding b&w portraits to the products you offer clients (or offering exclusively b&w). Learn to attract clients and deliver portraits that will keep them coming back. $29.95 list, 8½x11, 128p, 80 b&w photos, order no. 1677.

Infrared Wedding Photography

Patrick Rice, Barbara Rice and Travis Hill

Step-by-step techniques for adding the dreamy look of black & white infrared to your wedding portraiture. Capture the fantasy of the wedding with unique ethereal portraits your clients will love! $29.95 list, 8½x11, 128p, 60 b&w images, order no. 1681.

Photographing Children in Black & White

Helen T. Boursier

Learn the techniques professionals use to capture classic portraits of children (of all ages) in black & white. Discover posing, shooting, lighting, and marketing techniques for black & white portraiture in the studio or on location. $29.95 list, 8½x11, 128p, 100 b&w photos, order no. 1676.

Posing and Lighting Techniques for Studio Photographers

J. J. Allen

Master the skills you need to create beautiful lighting for portraits. Posing techniques for flattering, classic images help turn every portrait into a work of art. $29.95 list, 8½x11, 120p, 125 color photos, order no. 1697.

Watercolor Portrait Photography

THE ART OF POLAROID SX-70 MANIPULATION

Helen T. Boursier

Create one-of-a-kind images with this surprisingly easy artistic technique. $29.95 list, 8½x11, 128p, 200 color photos, order no. 1698.

Corrective Lighting and Posing Techniques for Portrait Photographers

Jeff Smith

Learn to make every client look his or her best by using lighting and posing to conceal real or imagined flaws—from baldness, to acne, to figure flaws. $29.95 list, 8½x11, 120p, 150 color photos, order no. 1711.

Make-up Techniques for Photography

Cliff Hollenbeck

Step-by-step text and illustrations teach you the art of photographic make-up. Learn to make every portrait subject look his or her best with great styling techniques for black & white or color photography. $29.95 list, 8½x11, 120p, 80 color photos, order no. 1704.

Professional Secrets of Natural Light Portrait Photography

Douglas Allen Box

Use natural light to create hassle-free portraiture. Beautifully illustrated with detailed instructions on equipment, lighting, and posing. $29.95 list, 8½x11, 128p, 80 color photos, order no. 1706.

Portrait Photographer's Handbook

Bill Hurter

Bill Hurter has compiled a step-by-step guide to portraiture that easily leads the reader through all phases of portrait photography. This book will be an asset to experienced photographers and beginners alike. $29.95 list, 8½x11, 128p, 100 color photos, order no. 1708.

Professional Marketing & Selling Techniques for Wedding Photographers

Jeff Hawkins and Kathleen Hawkins

Learn the business of wedding photography. Includes consultations, direct mail, advertising, internet marketing, and much more. $29.95 list, 8½x11, 128p, 80 color photos, order no. 1712.

Traditional Photographic Effects with Adobe® Photoshop®, 2nd Ed.

Michelle Perkins and Paul Grant

Use Photoshop to enhance your photos with handcoloring, vignettes, soft focus, and much more. Every technique contains step-by-step instructions for easy learning. $29.95 list, 8½x11, 128p, 150 color images, order no. 1721.

Master Posing Guide for Portrait Photographers

J. D. Wacker

Learn the techniques you need to pose single portrait subjects, couples, and groups for studio or location portraits. Includes techniques for photographing weddings, teams, children, special events and much more. $29.95 list, 8½x11, 128p, 80 photos, order no. 1722.

The Art of Color Infrared Photography

Steven H. Begleiter

Color infrared photography will open the doors to a new and exciting photographic world. This book shows readers how to previsualize the scene and get the results they want. $29.95 list, 8½x11, 128p, 80 color photos, order no. 1728.

High Impact Portrait Photography

Lori Brystan

Learn how to create the high-end, fashion-inspired portraits your clients will love. Features posing, alternative processing, and much more. $29.95 list, 8½x11, 128p, 60 color photos, order no. 1725.

The Art of Bridal Portrait Photography

Marty Seefer

Learn to give every client your best and create timeless images that are sure to become family heirlooms. Seefer takes readers through every step of the bridal shoot, ensuring flawless results. $29.95 list, 8½x11, 128p, 70 color photos, order no. 1730.

Beginner's Guide to Adobe® Photoshop®, 2nd Ed.

Michelle Perkins

Learn to effectively make your images look their best, create original artwork, or add unique effects to any image. Topics are presented in short, easy-to-digest sections that will boost confidence and ensure outstanding images. $29.95 list, 8½x11, 128p, 300 color images, order no. 1732.

Professional Techniques for Digital Wedding Photography, 2nd Ed.

Jeff Hawkins and Kathleen Hawkins

From selecting equipment, to marketing, to building a digital workflow, this book teaches how to make digital work for you. $29.95 list, 8½x11, 128p, 85 color images, order no. 1735.

Photographer's Lighting Handbook

Lou Jacobs Jr.

Think you need a room full of expensive lighting equipment to get great shots? With a few simple techniques and basic equipment, you can produce the images you desire. $29.95 list, 8½x11, 128p, 130 color photos, order no. 1737.

Professional Digital Photography

Dave Montizambert

From monitor calibration, to color balancing, to creating advanced artistic effects, this book provides those skilled in basic digital imaging with the techniques they need to take their photography to the next level. $29.95 list, 8½x11, 128p, 120 color photos, order no. 1739.

Group Portrait Photographer's Handbook

Bill Hurter

With images by top photographers, this book offers timeless techniques for composing, lighting, and posing group portraits. $29.95 list, 8½x11, 128p, 120 color photos, order no. 1740.

LIGHTING AND EXPOSURE TECHNIQUES FOR
Outdoor and Location Portrait Photography

J. J. Allen

Meet the challenges of changing light and complex settings with techniques that help you achieve great images every time. $29.95 list, 8½x11, 128p, 150 color photos, order no. 1741.

The Art and Business of High School Senior Portrait Photography

Ellie Vayo

Learn the techniques that have made Ellie Vayo's studio one of the most profitable senior portrait businesses in the US. $29.95 list, 8½x11, 128p, 100 color photos, order no. 1743.

The Art of Black & White Portrait Photography

Oscar Lozoya

Learn how Master Photographer Oscar Lozoya uses unique sets and engaging poses to create black & white portraits that are infused with drama. Includes lighting strategies, special shooting techniques and more. $29.95 list, 8½x11, 128p, 100 duotone photos, order no. 1746.

The Best of Wedding Photography

Bill Hurter

Learn how the top wedding photographers in the industry transform special moments into lasting romantic treasures with the posing, lighting, album design, and customer service pointers found in this book. $29.95 list, 8½x11, 128p, 150 color photos, order no. 1747.

Success in Portrait Photography

Jeff Smith

Many photographers realize too late that camera skills alone do not ensure success. This book will teach photographers how to run savvy marketing campaigns, attract clients, and provide top-notch customer service. $29.95 list, 8½x11, 128p, 100 color photos, order no. 1748.

Photographing Children with Special Needs

Karen Dórame

This book explains the symptoms of spina bifida, autism, cerebral palsy, and more, teaching photographers how to safely and effectively capture the unique personalities of these children. $29.95 list, 8½x11, 128p, 100 color photos, order no. 1749.

Professional Digital Portrait Photography

Jeff Smith

Because the learning curve is so steep, making the transition to digital can be frustrating. Author Jeff Smith shows readers how to shoot, edit, and retouch their images—while avoiding common pitfalls. $29.95 list, 8½x11, 128p, 100 color photos, order no. 1750.

The Best of Children's Portrait Photography

Bill Hurter

Rangefinder editor Bill Hurter draws upon the experience and work of top professional photographers, uncovering the creative and technical skills they use to create their magical portraits. $29.95 list, 8½x11, 128p, 150 color photos, order no. 1752.

Wedding Photography with Adobe® Photoshop®

Rick Ferro and Deborah Lynn Ferro

Get the skills you need to make your images look their best, add artistic effects, and boost your wedding photography sales with savvy marketing ideas. $29.95 list, 8½x11, 128p, 100 color images, index, order no. 1753.

Web Site Design for Professional Photographers

Paul Rose and Jean Holland-Rose

Learn to design, maintain, and update your own photography web site. Designed for photographers, this book shows you how to create a site that will attract clients and boost your sales. $29.95 list, 8½x11, 128p, 100 color images, index, order no. 1756.

PROFESSIONAL PHOTOGRAPHER'S GUIDE TO
Success in Print Competition

Patrick Rice

Learn from PPA and WPPI judges how you can improve your print presentations and increase your scores. $29.95 list, 8½x11, 128p, 100 color photos, index, order no. 1754.

PHOTOGRAPHER'S GUIDE TO
Wedding Album Design and Sales

Bob Coates

Enhance your income and creativity with these techniques from top wedding photographers. $29.95 list, 8½x11, 128p, 150 color photos, index, order no. 1757.

The Best of Portrait Photography

Bill Hurter

View outstanding images from top professionals and learn how they create their masterful images. Includes techniques for classic and contemporary portraits. $29.95 list, 8½x11, 128p, 200 color photos, index, order no. 1760.

THE ART AND TECHNIQUES OF
Business Portrait Photography

Andre Amyot

Learn the business and creative skills photographers need to compete successfully in this challenging field. $29.95 list, 8½x11, 128p, 100 color photos, index, order no. 1762.

The Best of
Teen and Senior Portrait
Photography
Bill Hurter

Learn how top professionals create stunning images that capture the personality of their teen and senior subjects. $29.95 list, 8½x11, 128p, 150 color photos, index, order no. 1766.

PHOTOGRAPHER'S GUIDE TO
The Digital Portrait
START TO FINISH WITH ADOBE® PHOTOSHOP®
Al Audleman

Follow through step-by-step procedures to learn the process of digitally retouching a professional portrait. $29.95 list, 8½x11, 128p, 120 color images, index, order no. 1771.

The Portrait Book
A GUIDE FOR PHOTOGRAPHERS
Steven H. Begleiter

A comprehensive textbook for those getting started in professional portrait photography. Covers every aspect from designing an image to executing the shoot. $29.95 list, 8½x11, 128p, 130 color images, index, order no. 1767.

Digital Photography for
Children's and Family
Portraiture
Kathleen Hawkins

Discover how digital photography can boost your sales, enhance your creativity, and improve your studio's workflow. $29.95 list, 8½x11, 128p, 130 color images, index, order no. 1770.

Professional Strategies
and Techniques for
Digital Photographers
Bob Coates

Learn how professionals—from portrait artists to commercial specialists—enhance their images with digital techniques. $29.95 list, 8½x11, 128p, 130 color photos, index, order no. 1772.

The Best of Wedding
Photojournalism
Bill Hurter

Learn how top professionals capture these fleeting moments of laughter, tears, and romance. Features images from over twenty renowned wedding photographers. $29.95 list, 8½x11, 128p, 150 color photos, index, order no. 1774.

Color Correction and
Enhancement with Adobe®
Photoshop®
Michelle Perkins

Master precision color correction and artistic color enhancement techniques for scanned and digital photos. $29.95 list, 8½x11, 128p, 300 color images, index, order no. 1776.

Fantasy Portrait
Photography
Kimarie Richardson

Learn how to create stunning portraits with fantasy themes—from fairies and angels, to 1940s glamour shots. Includes portrait ideas for infants through adults. $29.95 list, 8½x11, 128p, 60 color photos index, order no. 1777.

Creative Techniques for
Color Photography
Bobbi Lane

Learn how to render color precisely, whether you are shooting digitally or on film. Also includes creative techniques for cross processing, color infrared, and more. $29.95 list, 8½x11, 128p, 250 color photos, index, order no. 1764.